COLLINS • Learn to

Watercolour Landscapes

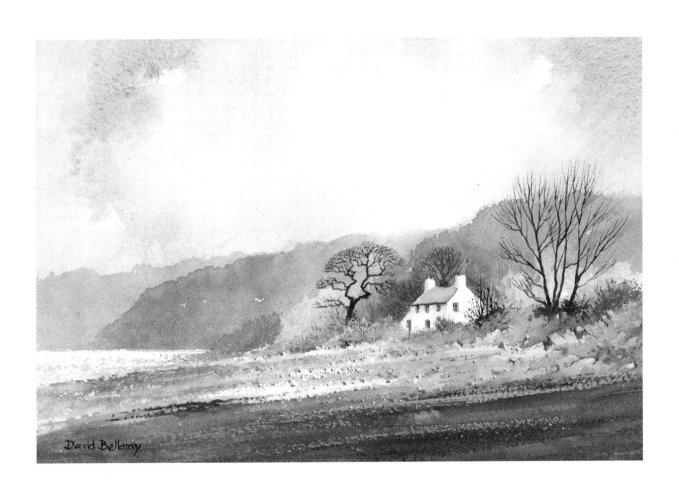

David Bellamy

DAVID BELLAMY

Dedication
This book is dedicated to the many students who have made my watercolour courses so rewarding.

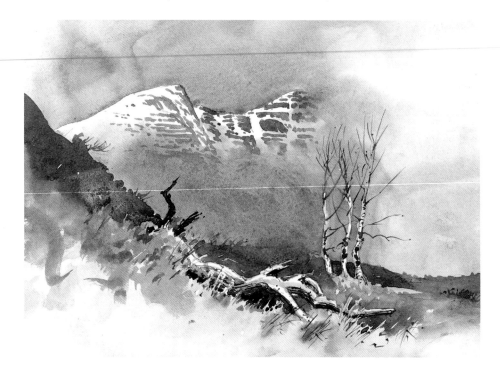

Acknowledgment
I am grateful to Jenny Keal for her constructive comments.

First published in 1999 by
HarperCollins*Publishers*
77-85 Fulham Palace Road
Hammersmith, London W6 8JB

The HarperCollins website address is
www.**fire**and**water**.com

00 02 04 03 01 99
2 4 6 8 9 7 5 3 1

© David Bellamy 1999

David Bellamy asserts the moral right to be identified as the author of this work.

A catalogue record for this book is available from the British Library.

Designer: Penny Dawes
Photographer: Laura Wickenden

ISBN 0 00 413326 9

Colour reproduction by Colourscan, Singapore
Printed and bound in Hong Kong.

Previous page: **Cottage near Lawrenny, Pembrokeshire,** 17 x 25 cm (6¾ x 10 in)
This page: **Applecross Mountains,** 16 x 22 cm (6¼ x 9 in)

Contents

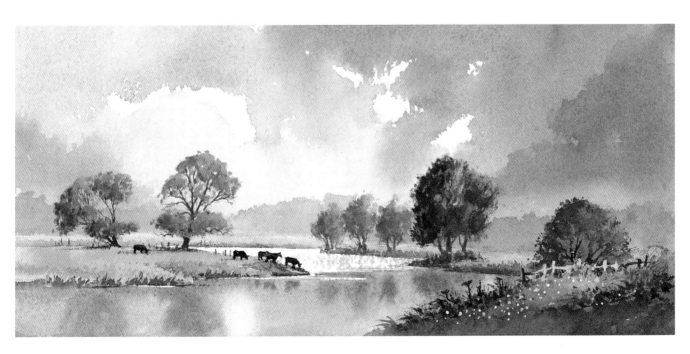

River Test, Hampshire, 13 x 28 cm (5 x 11 in)

Portrait of an Artist

David Bellamy was born and brought up in Pembrokeshire in Wales where the natural environment had a profound effect on him. Drawing was always a great feature in his spare moments, but painting did not come naturally to him.

During the time he worked in the computer industry he became drawn to climbing mountains. The sheer beauty of the wild environment enthralled him so much that he began to take a sketchbook and watercolour paints on his trips.

Battling against the excesses of rain, wind and snow, especially in winter, proved an interesting challenge – the watercolour sketches would often end up with the saturated pages stuck together, forming a damp mess at the back of his rucksack! Occasionally, the paintings would emerge much improved. Now and then a real gem appeared, usually with a little help from nature, and this encouraged him to persevere. Lightly spattered rain or textures formed by washes freezing can either enhance or ruin a watercolour sketch, making the resulting image quite unpredictable.

These experiences proved invaluable in learning how to combine the elements, sky, atmosphere and the mountains themselves in a painting. A sense of atmosphere is often a dominant feature of his paintings.

After a number of successful exhibitions he abandoned his work in computers to concentrate fully on painting and to write his first book, *Wild Places of Britain*. More books followed, including the highly successful *Watercolour Landscape Course*, together with a trilogy of how-to-paint

◀ David Bellamy doing a rapid sketch in Mid Wales.

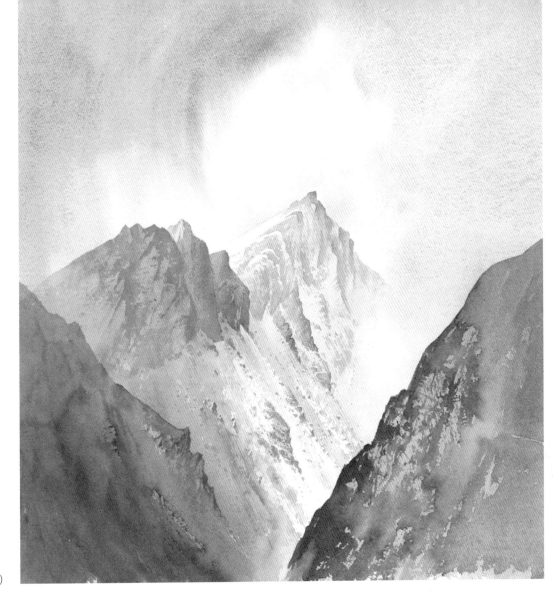

▶ Stob Coire
Sgreamhach, Glencoe
35 x 28 cm (13¼ x 11 in)

videos. David now also writes articles on the countryside and contributes to *Leisure Painter* magazine. He runs a variety of watercolour painting courses each year in various parts of the country, both for active students, who wish to walk and sketch, and for those who are less energetic.

David is deeply concerned about threats to the natural environment and he has become directly involved in campaigns to save prime landscape areas. He is a patron of the Marine Conservation Society.

David has also done much television work relating to both art and the environment. His latest series, *Painting Wild Wales*, on HTV Wales shows him painting and sketching, at times in the most appalling conditions, in an all-action sequence of locations typical of his subject matter: up mountains, slithering down waterfalls, crossing muddy estuaries, taking his pencils down caves and canyons, and much more. A video of the series is available from Clockwork Penguin.

It is this first-hand involvement with the energy, vitality and beauty of his subject matter, the need to feel the rain on his face, hands gripping rock, and the sensation of being close to a thundering waterfall that inspires his best work.

Painting Landscapes in Watercolour

Watercolour is the most exciting of painting mediums and it often seems to have a mind of its own. It is just as likely to create a gloriously beautiful effect or an unsightly muddy puddle! Whilst it can be thrilling to let the washes get slightly out of control and to hope the accidental runs will end in a positive result, I shall endeavour to show you how to get the most out of the medium. Hopefully, many of your accidents will end up as happy results.

Like most things, watercolour painting is far easier to cope with when the learning process is broken down into easy stages. If you follow the suggestions in this book, then you should begin to produce competent landscapes very quickly. Many of the rules and ideas illustrated here will act as guidelines whilst you are learning, but once your expertise develops, you may wish to discard some of them. I have broken most of the conventions on composition outlined in this book to good effect on several occasions.

Working through the book

This book aims to teach you the basic techniques of watercolour painting in an organized manner, starting in a simple way

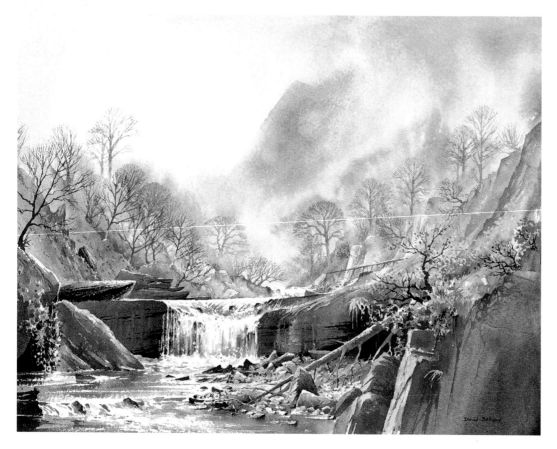

◀ **Waterfall, Cwm Clydach**
30 x 41 cm (11¼ x 16 in)

and gradually building up to more complicated scenes. Take each section a step at a time, trying out the techniques for yourself.

By practising each technique several times you will become more adept at it; you cannot expect to get all of them right first time. Large pads of cheap cartridge paper are a boon for this type of exercise because you will be less inhibited and be able to paint more freely. When you feel confident try copying the paintings, starting with the easier ones. Get yourself a dark-coloured rectangular mount to lay over your paintings to help you to assess when they are finished.

You will find that many of the chapters overlap. For example, there is one dedicated to skies, but since most of the paintings in this book are landscapes you will find other instances of skies throughout the book. So do look beyond the chapter you are studying to find other relevant examples.

Sketching

The sketching section deliberately comes towards the end of the book. This is because most beginners feel happier possessing a little experience before going out into the world with a sketchbook and pencil.

Whilst it can be daunting at first, going out to work directly from nature is the best thing that a landscape artist can do. I would suggest, therefore, that you become familiar with the basic techniques, copy paintings from the book and then, when you feel ready and in need of fresh material, go out on your own, or with a friend, in search of new subjects. The types of subject that you gravitate towards are important in your development as an artist. We all have certain preferences – mine is wild, untamed scenery – and finding what excites you most is vital as a source of inspiration.

In this book I have covered a wide range of subject matter found in the countryside. Once you have tried these subjects you may

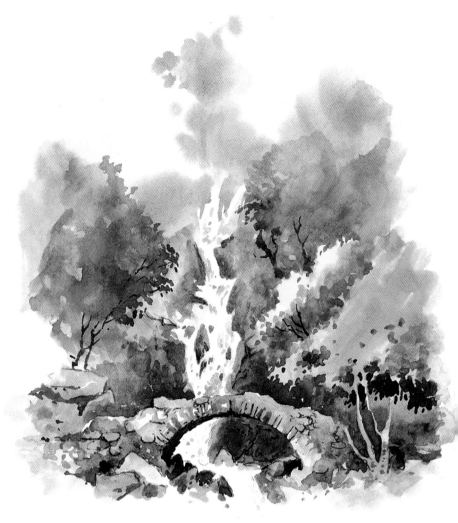

have a much clearer idea of what you wish to concentrate on, but to begin with try to paint as many different subjects as you can.

Drawing

I cannot over-emphasize the importance of drawing – this is especially valid in the case of the landscape artist. Continual practice at pencil drawing will reap rewards. Drawing a still life or scenes from a photograph, and taking every opportunity to draw outside, even if you go no further than your garden, will improve your draughtsmanship.

With practice everyone can improve their drawing skills, and it will certainly have a beneficial effect on your watercolours. Above all, don't become too discouraged if your paintings and drawings are not immediately successful; the more mistakes you make, the faster you will learn!

▲ **Packhorse Bridge, Glen Lyon**
26 x 21 cm (10¼ x 8¼ in)

Materials & Equipment

With such a wide range of art materials on the market today it is easy to waste money on unsuitable items. You do not need many items in order to make a start, and it is better to build up your kit as your drawing and painting skills develop.

Watercolour paints

Buying a box of 24 colours might seem a good idea – lovely colours in a pristine new box can look very tempting. However, it is far better to get a box of eight or ten colours, twelve at the most, so that you can experiment and get to know them. Once you are familiar with these you can add further ones to your basic set. Working methodically in this manner will speed up your learning.

Should you buy pans or tubes? Artists' quality or the student variety? The choice of pans or tubes is an individual one. I use a box of Daler-Rowney half pans for working out-of-doors because they are compact and quick to use. In the studio, however, I always work with tubes because I can squeeze out as much paint as I need for a particular mixture. Pans can inhibit the use of large brushes and it is so tempting to dip into a whole variety of colours (impulse dipping) as they lay before you in their pans. That, of course, might be fine for painting

▼ This is my basic watercolour painting kit. The paper is stretched on a drawing board ready for painting. Note the tray-type palette (bottom left) and the small china mixing well (bottom). Whilst I generally use tubes of paint, many artists prefer to use half pans.

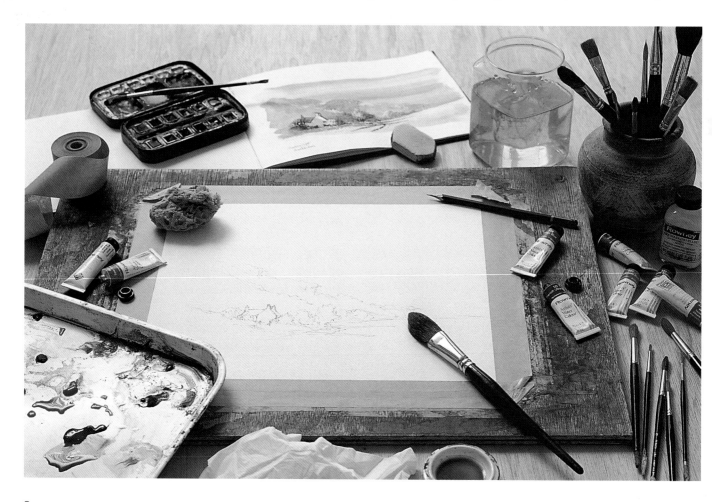

rainbows, but it is not conducive to good watercolour practice.

The following list of colours will provide you with an excellent starting repertoire for landscape work, and further into the book I shall add others to broaden your range. These are the ones I find indispensable:

Burnt Umber
Raw Sienna
Burnt Sienna
Cadmium Yellow Pale
Cadmium Red
Light Red
Cobalt Blue
French Ultramarine

Other colours you might find in a box are Chinese White, Viridian, Crimson Alizarin, Black, Monestial Blue and Gamboge. The use of white is discussed later on in the book. Viridian, although acid-looking on its own, is one of the better prepared greens to use for mixing, but I prefer to mix my own greens from primary colours. Crimson Alizarin is a beautiful colour, although it does tend to fade in weak washes. I do not use Black as it deadens colours with which it is mixed. Monestial Blue is a powerful colour and so I tend to use it more sparingly than the blues listed above. Gamboge is a lovely versatile yellow.

Students'-quality watercolours are cheaper than the artists' grade. If you are not sure how you will get on with watercolour painting, it seems prudent to buy a set of students'-quality watercolours to begin with, and then to upgrade when you feel that your work deserves the better quality paints.

Brushes

You will need a range of brushes: large ones for washes of colour, smaller ones for more detailed areas, and a rigger for fine detail. Squirrel-hair mop brushes hold a lot of

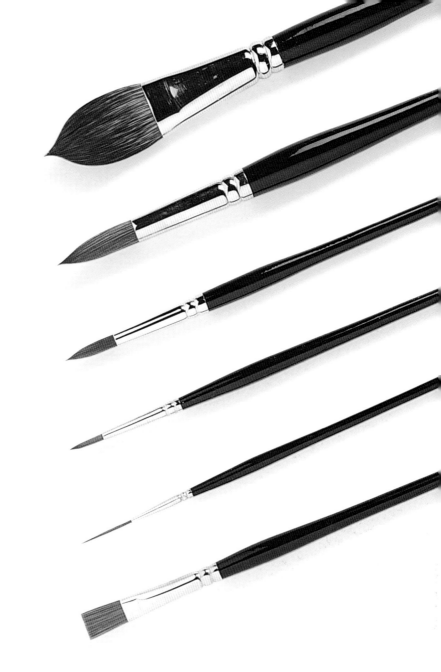

water, and they come in a variety of sizes. Buy the largest you feel happy with because the fewer strokes you use, the better and fresher your work will appear. Round brushes (Nos. 4, 8 and 12 in particular) are good to start with, plus a No. 1 rigger. This brush has long hairs and holds quite a lot of paint for its size. It is called a rigger because it was originally used for painting the rigging on ships.

The most suitable brushes for watercolour painting are sables because they point well and have a spring to them. Before buying, however, check that they come to a fine point by dipping them in water (which any good art shop should supply). Sables are the

▲ Types of brushes. From top: large squirrel-hair mop; No. 10 round; No. 8 round; No. 4 round; No. 1 rigger; half-inch flat.

most expensive type of brush but there are now many excellent synthetic alternatives on the market, including some sable/synthetic mixtures. Do rinse out your brushes with clean water after use and remember not to stand them resting on the brush hairs in your water pot.

Paper

Watercolour paper is generally available in three different surface textures and a variety of thicknesses, or weights. The most commonly used surface is called Not, or Cold-Pressed, which is useful for most landscape applications. The Rough variety, as it implies, has a rougher surface that is excellent for painting strong textural effects. Much less used for landscape work is Hot-Pressed paper which, being smooth, is more suitable for fine detail and pen-and-wash

work. Getting the most out of the various papers was a vital consideration before starting many of the paintings in this book.

The most common weights of paper are 180 gsm (90 lb), 300 gsm (140 lb), 410 gsm (200 lb) and 640 gsm (300 lb). The most popular weight of paper is 300 gsm (140 lb) but, unless you work on a very small scale, it does need stretching, otherwise it may cockle badly. The 640 gsm (300 lb) paper is similar to cardboard and, although it does not require stretching, it is more expensive. If you do not wish to stretch paper, you may wish to use the 410 gsm (200 lb) variety.

Paper can be bought in sheets, pochettes (envelope-shaped packages), pads or blocks according to preference. Pochettes usually contain a variety of weights and surfaces of paper and can be helpful when you are deciding which to use. You need to try a

▲ A range of watercolour papers. Clockwise from top left: block of Saunders Waterford 300 gsm (140 lb) – blocks are glued at the edges and their advantage is that they do not need stretching; Daler-Rowney A5 cartridge pad; spiral bound pad of Bockingford 300 gsm (140 lb) Not; fan of multi-coloured Bockingford 300 gsm (140 lb) paper.

variety of papers before you can expect to make a sensible decision on what suits your needs best. The blocks are glued at all four edges to remove the need for stretching the paper, each sheet being peeled off once the painting is complete. Most of the paintings in this book were done on Saunders Waterford papers.

Stretching paper

Unless you work on 410 gsm (200 lb) paper, or heavier, you will no doubt find that it cockles alarmingly when you paint large washes. Whilst this does not matter when you are working on exercises, it can diminish the quality of a finished painting. To stretch a sheet of paper cut it to the appropriate size for the painting and immerse it totally in water for a few seconds. Holding it up by one corner let the excess water drip off and then lay it flat on a drawing board. Using pre-cut strips of gummed tape, fix each edge of the paper to

the board and leave it to dry for several hours in a horizontal position. This results in a lovely taut surface. If you find the paper pulls or tears away from the tape, the paper has been immersed in the water for too long.

Other items

You will need at least one drawing board, a selection of pencils, a large palette or white saucer, a putty eraser, paper tissues, masking fluid, a water container and a natural soft sponge. For working under artificial light, a daylight bulb (sold in art shops) is excellent, since normal lighting is too warm in colour temperature.

For sketching outdoors, remember to keep your equipment simple and start with just pencils and a pad. Once you progress onto watercolour painting the selection of equipment shown below is more than adequate.

▶ Here is my outdoor sketching equipment. I use a Daler-Rowney compact watercolour box. My brushes and pencils are held in a strong tube, the top of which holds painting water. A rectangular cardboard viewfinder can be helpful to isolate your subject from the surrounding mass of detail. I work watercolour sketches on a cartridge pad or in a watercolour book. I also use a closed-cell foam pad for sitting on, available from outdoor shops. Keep your sketching equipment simple and start with just pencils and pad.

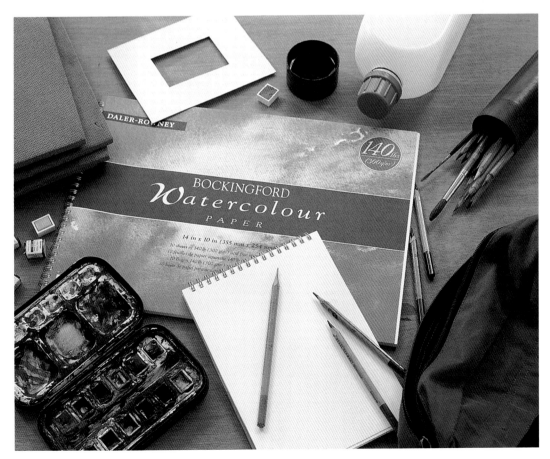

Watercolour Techniques

Watercolour is a transparent medium. Unlike oils or acrylics you cannot paint lighter colours over a passage of dark paint, so you need to begin with the lightest shades and gradually build up the colour by laying one wash over another. By breaking down the process of producing a watercolour into a number of stages you can make life easier for yourself and, with practice, become freer in expressing a scene.

Laying a flat wash

The first technique you need to learn is how to lay a wash of colour across a piece of paper. Normally this is done during the early moments in the life of a painting, covering large areas such as skies or mountains. For this use a large brush and mix a pool of liquid colour in a saucer or palette well. Make sure it is all liquid and there are no blobs lurking under the surface intent on springing nasty surprises as your brush travels across the paper. Do test the strength of your wash on scrap paper before applying it to a painting.

Position your drawing board at a comfortable angle by placing books or similarly solid items beneath it. This will allow the wash to flow freely down the paper and lessen the likelihood of runbacks forming. These dreadful cabbage-like creatures mysteriously emerge from your washes when water seeps back up into your drying wash.

To lay a wash, charge the brush from the pool of colour and draw it across the surface of the paper, preferably in one movement. Immediately follow on down the paper, slightly overlapping the previous limit with each successive stroke. At the bottom you will most likely find beads of

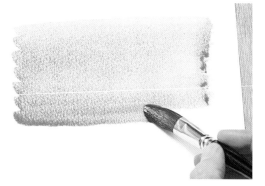

◀ To lay a flat wash ensure the board is at an angle to enable the colour to flow. Mix a pool of colour and work down the paper, slightly overlapping the previous layer with each stroke. Use a minimum number of strokes.

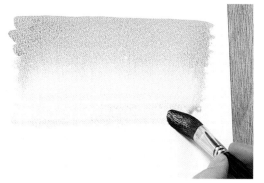

◀ To lay a graduated wash, that is, a wash that becomes lighter in tone with each new band of colour applied, simply add more water to the brush as you progress with the wash.

liquid forming. Mop these up quickly with a barely damp brush before they spill over or cause runbacks.

Blending colours in a wash

One of the charms of watercolour is in letting the medium have its way, particularly with regard to washes. One effective technique is to blend a dark upper sky into a lighter area below – see the example at the top of page 13. Begin with a very wet wash of weak Cadmium Yellow Pale in the lower half of the sky, then bring it down over the distant hill. Immediately, whilst the wash is still wet, lay a mixture of Cobalt Blue and Cadmium Red over the top part and then bring the wash down until both washes overlap slightly. Sit back and watch the results, and on no account interfere

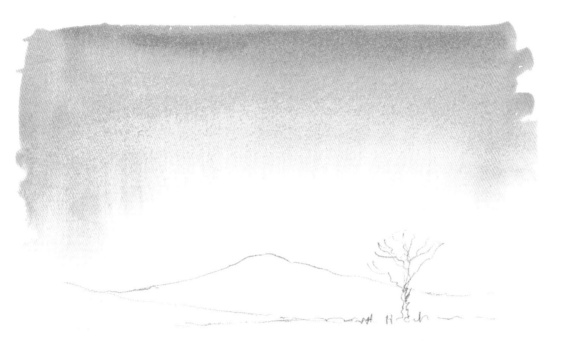

◀ In this example colours are blended together in a wash. Because the hill in the finished painting will be darker than the sky you can happily allow the wash to flow down over the pencil marks. If you tried to stop the wash right on the hill ridge line, an ugly margin would probably appear once you painted in the hill.

with the wash whilst it is drying.

Improve your skill level by making a number of attempts at each of the techniques mentioned.

Working on wet paper

If you paint into a wet surface, the edges will soften and bleed into the wet area. Unless you deliberately want this effect it can have a disastrous effect on your paintings, but when employed as a technique it can produce exciting soft images. Controlling it, however, can be tricky, so it does take some experience to handle this technique with confidence.

Variegated colours

The first use for dropping further colours into a wet area is to create a pattern of colours, each blending into what has already been laid. This treatment is extremely effective in creating a variegated effect on a wall, depicting the different colours in rock formations, adding interest to a mountain or hillside, creating a patch of moss or lichen on an ancient roof perhaps, or forming a variety of colours in a hedgerow. The possible applications are endless.

The aim of this technique is to add a variety of colour without making it a dominant feature. It is a superb device to use for a monotonous feature, such as a wall, hedgerow or sloping ground, where some detail has been painted in, but too much would overwhelm the eye of the viewer. By substituting excess detail with variation in colour you can create interest in a more subtle way.

This technique works best where the extra colours are dropped into the wet wash immediately, without waiting for it to

▼ Various colours were dropped into the original wash of French Ultramarine and Raw Sienna whilst it was still wet. When it was dry some darker shadow areas were introduced on the right. Finally, with a dark mixture of Burnt Sienna and French Ultramarine some of the stones were painted in detail.

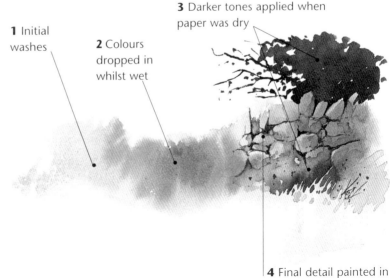

3 Darker tones applied when paper was dry

1 Initial washes

2 Colours dropped in whilst wet

4 Final detail painted in

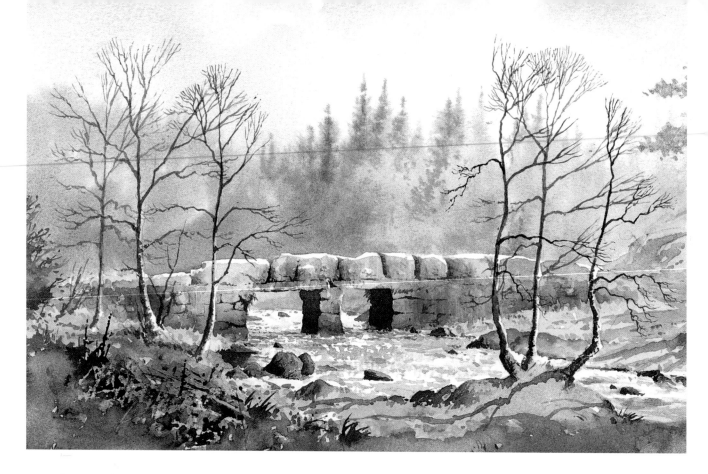

start drying. There is less chance of runbacks forming, unless you deliberately want them. Experiment on scrap paper before you try the technique in a painting. Mop up any excess water with a damp brush.

Wet-into-wet

The main reason for painting on wet paper is to create soft images, such as features barely showing through mist, clouds, reflections in water or distant atmospheric hills. This wet-into-wet technique takes some experience before it can be handled with assurance – the basic problems are knowing when to drop in the second wash and how strong to make the mixture.

For instance, to create soft-edged clouds simply wet the sky area with clean water and then drop in the blue or grey colour which represents the areas in between the white clouds.

Woodland scenes generally benefit from the wet-in-wet technique where the background trees and bushes are rendered whilst the overall wash is still wet. You need to wait until the wash is starting to dry, otherwise the images of background trees

will become lost in the wetness. Make sure that the paint mixture you are about to brush into the wet wash does not hold much water. It needs to be damp with a strong mixture of paint. With a complicated area, do not try to achieve too much in one go – you can always let the paper dry and then re-wet it to have another attempt at the technique.

Creating white spaces

Many watercolourists feel the need to cover every bit of their paper with paint. However, this tends to take away the sense of freshness and spontaneity that is the hallmark of a good watercolour. Flecks of white paper here and there are the very soul of a watercolour, bringing it to life.

Because it is difficult to recover a pure white surface once it has been painted over, these white areas are best planned in advance.

Recovering white areas

White areas can be blotted out with tissues whilst the paint is still wet, but the result is dependent on the pigments used: staining

▲ **Lethertor Bridge, Dartmoor**
18 x 21 cm (7 x 8¼ in)
The soft background trees contrast sharply with the hard edges of the clapper bridge, emphasizing the latter as the focal point. The conifers were painted whilst the sky wash was still damp.

pigments, such as Crimson Alizarin or Viridian, are almost impossible to remove from the paper completely.

The sponge is another useful tool for restoring white. Make sure that the paint is dry and then use clean water and a soft natural sponge.

Sponging can be effective when used in conjunction with some sort of mask. Two pieces of thin card placed almost together can be held across a dark area of paint which has dried, and the damp sponge drawn up and down along the gap two or three times. By quickly mopping it dry with a tissue, a fine white line appears – a useful technique for creating a white mast. Corners of buildings, light shorelines of lakes and many other applications can be emphasized in this manner.

Masking fluid

By painting masking fluid over the areas you wish to keep white, you can paint over them and then rub off the masking fluid when the paint is dry.

Apply the masking fluid with an old brush and immediately wash the brush in warm soapy water, as the masking fluid can harm the hairs. A dip pen can be used for fine detail – see the *Cottage at Kinnersley* demonstration on page 48 for this particular technique.

White paint

White paint, such as Chinese White or White Gouache, can be used in small quantities to suggest white masts, seagulls, flecks of white flowers and many other small features, but when used in large amounts it can detract from a watercolour. The only time when any greater amounts of white paint can be effective is when you wish to paint on tinted paper, where the highlights need to be brought out. If you do use white paint, use it sparingly and apply it at the end of the painting, otherwise any other colours running into it will turn milky.

As a last resort, if you are painting on normal white paper, a knife or scalpel can scratch out a highlight, creating a sense of sparkle, tidying up a distant shoreline or creating a wire fence. It is best not to rely on this technique and only use it if all else fails. Again, wait until everything has been painted before scratching the surface.

Experiment with masking fluid on cartridge paper and try some of the techniques for recovering the white of the paper.

▶ **Pembrokeshire Cottages**
20 x 29 cm (8 x 11½ in)
The cottages, and some of the trees, were covered initially with masking fluid – for such fine work you may find a dip pen works well. Strong dark washes accentuate the whiteness.

Colour

With such a large number of colours available it can be confusing trying to work out how to cope with so many. As mentioned in the materials section, this is best carried out methodically with a limited number of colours. Before going further it is worth looking at the theory behind colour mixing.

Colour theory

You may have already come across terms such as primary and secondary colours, complementary colours and colour temperature. Primary colours are red, yellow and blue. When any two of these are mixed together they produce secondaries: red and yellow produce orange, yellow and blue make green, and blue and red combine to create purple. If a primary colour is

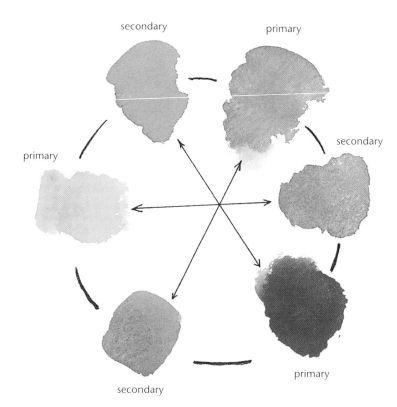

secondary primary

primary secondary

primary

secondary primary

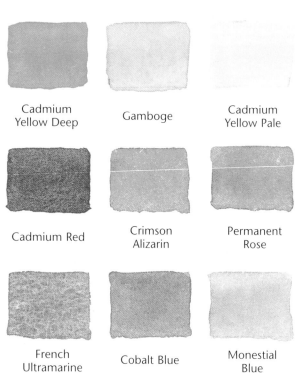

Cadmium Yellow Deep Gamboge Cadmium Yellow Pale Naples Yellow

Cadmium Red Crimson Alizarin Permanent Rose

French Ultramarine Cobalt Blue Monestial Blue

▲ The three primary colours of red, yellow and blue are seen on this simplified colour wheel, with each of their resulting mixtures shown between the appropriate colours. For example, orange appears between red and yellow, and its complementary, blue, is indicated opposite by the arrow.

◄ Here you can see various shades of yellow, red and blue. The warmest in temperature is positioned to the left in each case. Remember that, in a painting, cool colours recede.

mixed with a secondary colour the result is known as a tertiary colour.

Complementary colours are those found directly opposite each other on the colour wheel, such as blue and orange. If complementaries are placed together they give a more striking impact to a feature. An effective example of this is seen in *Autumn Tints on the Canal* on page 30.

Colour temperature refers to the warmth or coolness of a colour. Whilst reds and yellows tend towards warmth and blues, greens and greys towards the cool, all these colours vary in degree. Permanent Rose, for example, is a cooler red than Cadmium Red. Cool colours will suggest recession, so by using blues and greys for the more distant parts of a scene and warmer colours in the foreground, you can create the illusion of depth.

Abutting warm and cool colours can suggest warm sunshine or cold snow. For example, a small area of warm-coloured sky can make a landscape covered in snow suggested by cool blues and greys appear even colder.

Colour mixing

Before you attempt any mixing it is worth looking at some basic considerations regarding colour mixing. Firstly, keep all your colours clean: generous portions of muddy colours taken from the palette will not enhance the freshness of your mixtures. Secondly, it is best to try to achieve the colour you require by mixing only two colours. Sometimes, of course, you do need to use a third, but keep it to a minimum. Using any more colours will simply produce muddy mixtures.

Thirdly, in order to lighten a colour or a colour mixture add water not white paint. White should only be used on its own and not mixed with other colours because it makes them appear milky and opaque. Mixing colours with white will totally lose the fresh and vibrant appeal of watercolour.

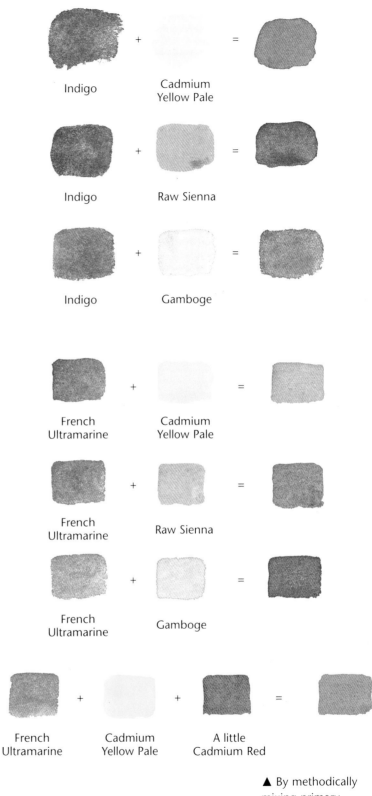

Indigo + Cadmium Yellow Pale =

Indigo + Raw Sienna =

Indigo + Gamboge =

French Ultramarine + Cadmium Yellow Pale =

French Ultramarine + Raw Sienna =

French Ultramarine + Gamboge =

French Ultramarine + Cadmium Yellow Pale + A little Cadmium Red =

▲ By methodically mixing primary colours together you can ascertain which combination produces the green which will best serve your purpose.

▼ This diagram illustrates the effect of mixing a number of dark colours with French Ultramarine to create a series of four greys, progressing in degrees of warmth from left to right. The colour temperature is most evident in the top sky areas. Try this exercise for yourself. First wash Naples Yellow over the central area – very wet. Then drop in the grey wash above Naples Yellow and allow to run down into it. Paint the hard-edged background ridge with the same grey in each case, and overlap the dried wash of Naples Yellow. Paint on darker mixes of the same greys when the paint is dry, then soften into Raw Sienna at the bottom.

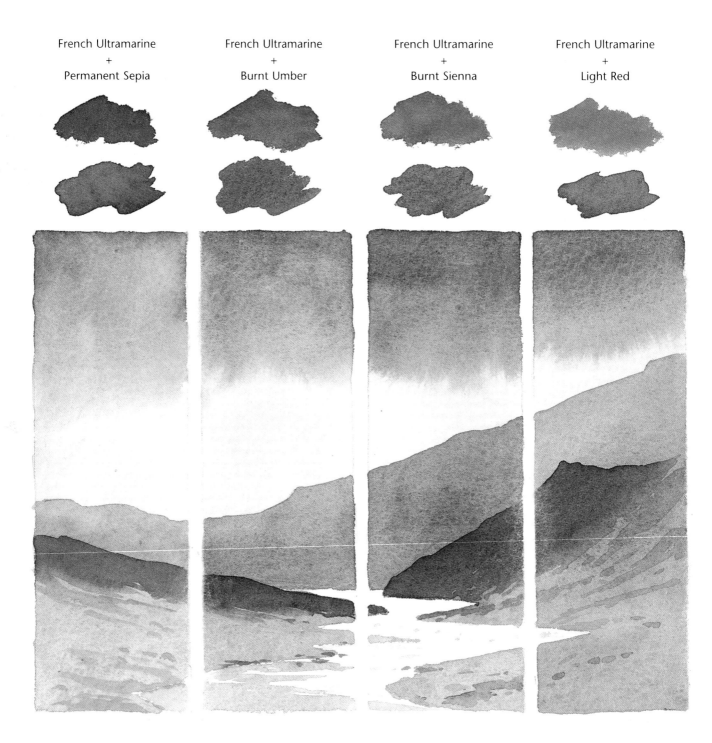

French Ultramarine
+
Permanent Sepia

French Ultramarine
+
Burnt Umber

French Ultramarine
+
Burnt Sienna

French Ultramarine
+
Light Red

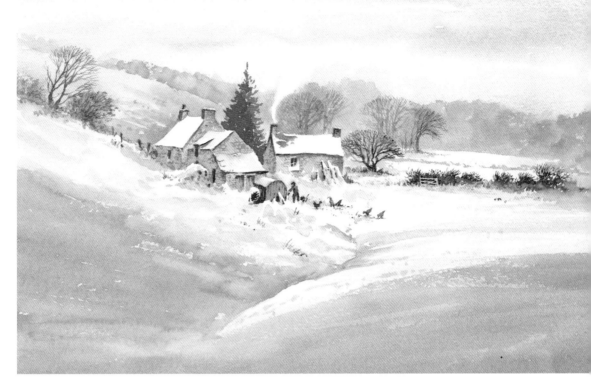

▶ **Winter at Ponde, Brecknockshire**
21 x 31 cm (8¼ x 12¼ in)
A snow scene benefits from the use of warm colours in places – the sky is an obvious choice. Here, the Raw Sienna on the walls, hedgerows and chickens helps to counter the stark coldness, further aided by the warm grey of the background trees.

A methodical approach will help you to learn what can be achieved by combining various colours. Take a sheet of cheap cartridge paper – an A4 pad is ideal – and paint a dab of French Ultramarine near the top. To a clean part of your palette or saucer take some more French Ultramarine, wash the brush clean and then add approximately the same amount of Cadmium Yellow Pale. Each time have a generous amount of water on the brush to make the paint flow. Mix the colours well and then apply the mixture as another dab below the French Ultramarine dab. Next, make a similar mix using Raw Sienna and French Ultramarine and continue down the paper, each time noting the colours mixed.

Continuing in this way, you can mix all your colours with French Ultramarine to see what each mixture produces. Of course, if you increase the amount of one colour the resulting mixture will change. Try this experiment several times using a different base colour for each new sheet of paper.

Some colours mix better than others. For example, Naples Yellow is quite opaque and in watercolour painting it is a poor mixer, with the mixture usually resulting in a milky appearance. It is best used on its own because it is excellent for subtly warming up

skies, or for dried grasses. Paints produced by different manufacturers can vary considerably, even colours with the same name, so it is wise to work through your colours methodically to see how they react in various mixes.

It is not necessary to slavishly copy the colours you see in nature. Colour is affected by light – one moment it can appear drab and then suddenly it can come alive when the sun emerges. You may wish to brighten a colour next to the focal point and subdue one in the foreground. Therefore, when you are mixing colours an approximation will suffice in most cases.

▼ Black paint deadens a painting, so to create strong darks use a mixture of colours. In this instance I used French Ultramarine and Burnt Sienna to produce a powerful dark.

Tones

When you start painting in any medium you will become aware of the following terms: tones, tonal values, value. Basically, they all mean the same thing, that is, the degree of darkness or lightness of a colour or feature within a painting. Each colour has its own range of tones. Cadmium Yellow Pale, for example, has a much lower range than Burnt Umber, the latter being so much darker.

Whatever medium you work in, however, the range of tones is very small compared to those found in nature. It is impossible, of course, to achieve the brightness of the sun. To a certain extent, therefore, you have to compromise.

At this early stage it is helpful to forget about colours and simply to concentrate on coming to terms with tones. This can be achieved easily by carrying out a monochrome painting, using perhaps only

▲ These tonal scales demonstrate how many more tonal variations can be achieved with Burnt Umber than with Cadmium Yellow Pale.

Burnt Umber. *Under the Cotswold Escarpment* has been achieved using this method, but first try the slate fence example shown opposite. When you paint a monochrome, work from light to dark as with a normal watercolour.

Get the tone right first time

It takes experience to achieve good results with tones, partly because watercolours tend to lighten in tone as they dry out,

▶ **Under the Cotswold Escarpment**
12 x 15 cm (4¾ x 6 in)
This was painted using only Burnt Umber. Using a dark colour to paint a monochrome will help your progress as you do not need to concern yourself with colour selection. This allows you to concentrate on tones.

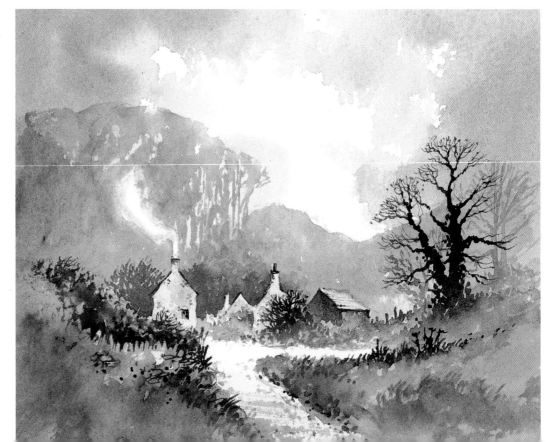

some pigments more so than others. Payne's Grey can be wayward in this respect, ending up far lighter than when it is applied.

It is important to try and get the tone right first time and not to take the attitude that 'I can always lay a darker wash on top if this one ends up too light'. Inevitably, it *will* end up lighter and another wash will be required, sometimes even more. After a number of gradually increasing darker washes you will almost certainly end up with a muddy colour!

Avoiding the linear look

One of the most important lessons to learn is that although you may be used to drawing with a pencil or pen, which are linear tools, it is tone that defines the features within a painting, not line. In nature, the edges stand out not because Mother Nature has drawn convenient lines around each object, but because the light is creating different tones according to whether the object is reflecting or absorbing light, the various angles and the local colour. A red roof against a dark green mass of trees may look obvious when seen 25 cm (10 in) away as you paint it, but from 2 m (79 in) or more it can become lost if the

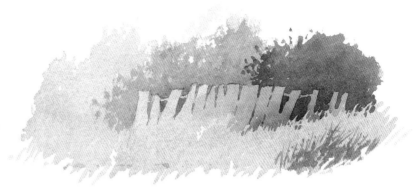

▲ Grey slate fences are peculiar to Snowdonia, and this watercolour sketch depicts one against a variety of grey backgrounds. The tones are increasing in strength towards the right, making the right-hand side of the fence appear closer.

tones are the same, even with two completely different colours.

Light does play tricks on us, changing tones as the various elements are caught in sunlight and shadow – an up-turned black-tarred Irish curragh lying near the beach can be the lightest part of a scene if it is caught glinting in sunlight. Therefore, you do have to modify tones and colours according to the light effects. Once you begin to make effective use of tones, you are well on your way to producing good watercolours.

▶ This rough pencil sketch illustrates clearly how using tones to define objects gives a more natural appearance than relying solely on pencil lines.

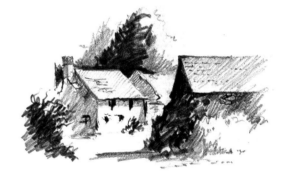

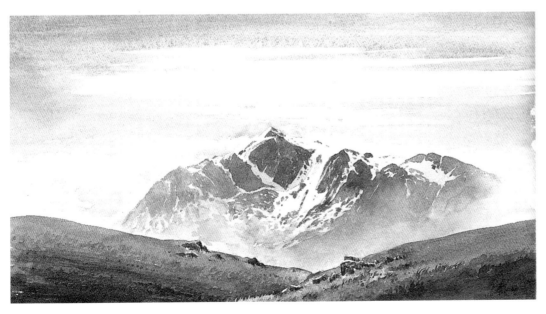

◀ **Bow Fell, Lake District**
19 x 34 cm (7½ x 13½ in)
Because there is little colour in this painting, it relies primarily on tonal variation for its strength. In a scene like this it is important to compare the foreground dark tones with those on the mountain to achieve a sense of recession.

Composition

Composition relates to the way in which you build up a painting – where you put each feature, how much emphasis you give it, how big, how small and how each item relates to its neighbour.

When considering the composition, you need to ask yourself several questions. Do you want to emphasize peace and tranquillity, or perhaps dynamism and drama? Is a vertical – portrait-style – format best, or a horizontal one? Perhaps an elongated view would yield optimum results. For peace and tranquillity the horizontals should dominate, whilst drama is suggested more by verticals.

Just as it is useful to jot down notes before writing an essay or a report, it can help enormously to commit your ideas to paper before beginning a painting. For this, studio sketches are critical.

The studio sketch

Once you have mastered the compositions in this book try working from your own sketches or photographs.

When painting from photographs, it is helpful in most cases to produce a studio sketch to ascertain the focal point, how it needs to be emphasized, supporting elements, what can be added or omitted, how high to place mountains, trees, cottages, and so on. At this point, you can also consider the main tones and how each feature will relate tonally to its neighbour.

Studio sketches can also be useful if your original sketch is complicated or you are working from more than one sketch or photograph. This can happen, for example, if you wish to include animals or figures that did not appear in the original scene.

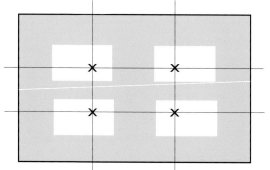

◀ The optimum position for the focal point is roughly one-third from two of the four edges of a painting, as marked by the crosses. The areas marked in green are not suitable for a focal point.

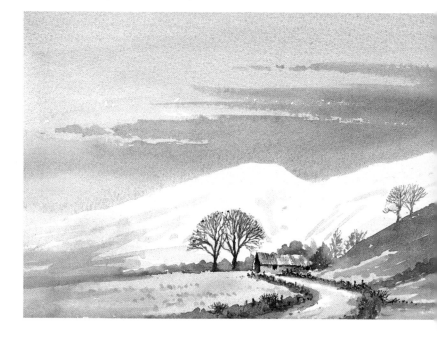

When you are happy with your design, transfer it to watercolour paper.

The centre of interest

Composition is discussed extensively throughout the book, but here it is beneficial to consider some general points. Most importantly, however beautiful a scene may be, without a focal point it is unlikely to appeal as a painting. Where this centre of interest is placed is of great importance – study how this has been done in the paintings in this book.

▲ **Barn in the Black Mountains**
18 x 25 cm (7 x 10 in)
The focal point in this scene is the barn. The road, dark ridge descending from the right and the left-hand hedgerow help to emphasize its importance. Bright, warm colours and strong tonal contrasts also help to accentuate the focal point.

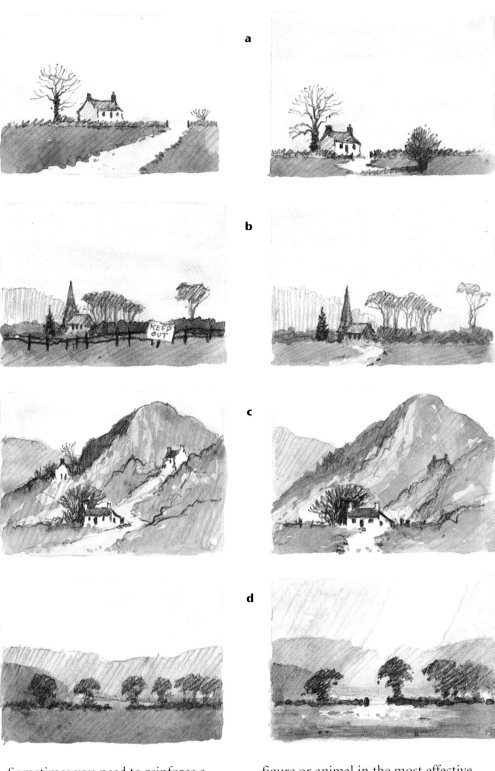

◀ These diagrams show you some of the more common composition problems and give you an idea of how they can be improved. In each case, the right-hand diagram offers an improved format.

a: The cottage is too central and the path leads away from it. By moving the gate up to the cottage, the path can lead directly to the building. A bush on the right helps to balance the composition.

b: A fence, hedgerow, wall or other obstruction across the foreground will inhibit the eye of the viewer resting on the centre of interest. Keep your foregrounds simple.

c: Here there are too many competing features. By subduing or eliminating some buildings, the main cottage stands out as the focal point.

d: Sometimes it is difficult to pick out a centre of interest in a scene. Here, one tree has been emphasized by making it stronger in tone in comparison with the others. The sky and lighting also help to highlight it.

Sometimes you need to reinforce a feature in a painting by making it much more prominent and supporting it with other items. Light, shadow and tonal contrasts are powerful ingredients in this respect.

There are times when you need to create a centre of interest by, for example, adding a figure or animal in the most effective position. Lines, such as mountain ridges, harbour chains, hedgerows and fences, can accentuate the importance of the focal point if they lead the eye towards it – roads, tracks and rivers are especially powerful in this respect. This lead-in can often make or break a composition.

Creating Recession

Trying to create a three-dimensional scene on a two-dimensional surface is not an easy task. A landscape painting needs to suggest a sense of depth and space, whether it is a wide panorama or a more intimate view.

In order to achieve this you need to adopt a number of techniques. In a scene of distant hills, for example, which has a great sense of spaciousness, you can see that, with a little observation, atmosphere, in the form of mist, heat haze, snowfall or rain, will modify how you observe the more distant objects. Objects seen far away tend to become more blue-grey as they recede, and also to lose detail.

With a more intimate subject, such as a woodland scene, a bend in the river or perhaps a farmyard, you would normally have to emphasize or even create a sense of depth, so that objects stand out. In effect,

you are compressing the space element. This approach not only suggests distance, but helps to avoid too much clutter by reducing the amount of detail.

Emphasizing recession

There are four basic elements that affect the sense of recession: colour temperature, tone, detail and the relative size of objects. Cool colours, such as blues or greys, emphasize a sense of distance, whilst warmer colours, such as reds and most yellows, come forward. Darker tones appear to be closer because objects tend to lighten in tone as they become more distant. Detail acts in the same way.

Colour temperature and tone, however, can work both ways. In a scene where the distance is warmer than the foreground you will need to counter this with strong tones

▶ **Nedd Fechan River, South Wales**
14 x 18 cm (5½ x 7 in)
In more intimate scenes, where the detail is compressed into a smaller area, you normally have to emphasize the feeling of depth by exaggerating the atmosphere. In the actual subject there was barely any tonal difference between the closest and furthest trees as they were not far apart. By creating a strong sense of misty atmosphere the painting retains an appearance of depth.

▶ **Brentor, Dartmoor**
24 x 33 cm (9½ x 13 in)
Brentor is barely visible, a cool and featureless blue-grey colour, whilst the ridges below it are slightly warmer and stronger in tone. This creates a sense of recession, with the strongest tones and detail on the trees and foreground further contributing to the sense of spaciousness. The surface texture of the paper – Waterford Rough – helps to suggest the ragged cloud edges and dry-brush effect below the gate.

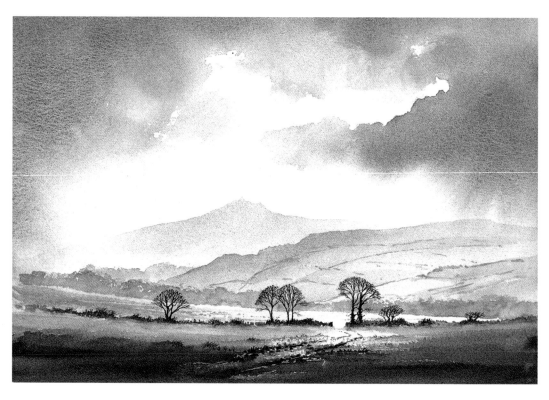

▲ Lindisfarne, Northumberland
10 x 17 cm (4 x 6¾ in)
In this painting, a cool background and warm foreground help to suggest depth.

and detail in the foreground. If there are powerful darks in the distance – a cloud-covered mountain, for example – then warmer foreground colours and detail will effectively retain a sense of recession. Familiar objects such as trees, houses, animals, fenceposts and so on, appear smaller in the distance. You can easily check these points out for yourself, choosing a variety of different atmospheric days to look at the landscape.

When you have identified the focal point, you must consider how your treatment of it will affect the sense of recession. If the focal point is in the middle distance, or further away, you still need to give it appropriate emphasis in terms of strong tonal contrast and perhaps bright colours, but this will need to be countered by stronger tones or detail in the foreground.

Simple Perspective

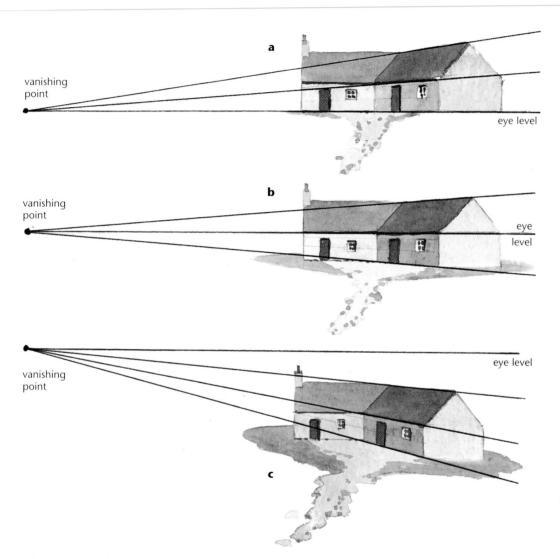

vanishing point

eye level

a

vanishing point

eye level

b

vanishing point

eye level

c

◄ These views show how perspective is altered at three different eye levels. At **a** the eye level is at floor height, so you are looking up at the house. Note that the higher you look above the eye level, the greater the angle of the line that extends to the vanishing point. At **b** the line of the eaves is at eye level. At **c** you are high above the building looking down, which accentuates the angles of the right-hand section even more than in **b**. In each case, the left-hand part of the building has remained more or less the same as it is directly in front of you and its horizontal lines are running parallel with your horizon – a useful point if you want to make life easy for yourself!

Linear perspective does not play a major part in landscape painting, and where it does impinge on the composition, you can effectively reduce its impact. Nevertheless, it is prudent to have a basic understanding of how perspective affects the objects you wish to include in a painting.

Buildings

Buildings, especially those in close proximity to one another, tend to present the most obvious perspective problems. By pushing them further back into a composition they become easier to render, mainly because the acute angles are simplified. There is a natural tendency to draw or paint buildings that are too large, so it is worth studying the paintings in this book which include buildings – the majority are quite small in relation to the size of the painting.

Perspective problems can be exacerbated further by trying to draw ancient structures that sag or lean to one side, making the perspective look incorrect even before you

begin. I usually exaggerate this type of effect because it tends to add character and also to make the effect so obvious that the viewer realizes the building is intentionally wayward.

It is, of course, the horizontal lines that create difficulties, since all vertical lines should remain vertical. When a building is some distance away it is not easy to see much variation in the horizontal lines, and in these cases it usually helps to draw these lines as if they were horizontal, even if they vary slightly in angle.

If you are working with the subject in front of you, then holding a pencil horizontally in front of your eye helps you to judge how true the main lines are. It cannot be a perfect guide, but it is usually adequate. If the building is a considerable distance above or below your eye level, you will get some distortion, especially if you are observing at some distance to one side of the building.

Shorelines

The shorelines of lakes and rivers can, at times, induce strange effects and, if you are not careful, your paintings can make the

▶ Many students emphasize the curves of the shoreline of a lake and so give a sense of looking down from a great height, as in **a**, when in fact they are standing beside the bank. By flattening out the shorelines, as in **b**, the final image is much more pleasing.

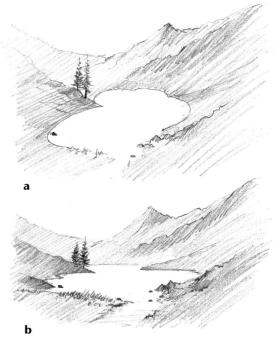

water look as though it is flowing over the edges and onto the banks. To create a pleasing composition of a large expanse of water, you have to resort to certain artificial devices at times in order to make the whole scene look authentic. Take care in rendering the banks and adjacent features.

Creating minor intermediate promontories is a device that can enhance a shoreline lacking in interest and it can also improve the perspective, as shown in the lake studies above.

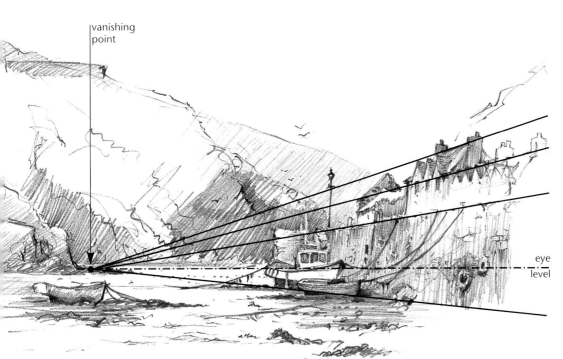

◀ **Fishguard Harbour, Pembrokeshire**
17 x 29 cm (6¾ x 11½ in)
The perspective in harbours can be very difficult. Establish your eye level by using a pencil held horizontally at arms length and closing one eye. It won't be precise, but it will give you an idea of where things fit. Note that, the higher or lower the lines are from your eye level, the more acute the angle to the vanishing point.

27

Painting Trees

Trees form such an important part of the landscape that it is worth devoting time and effort to learn how to paint them. A lovely river scene, for example, will be spoilt by a backdrop of trees that look like sticks of semi-shredded celery. Trees can be the centre of interest, a supporting feature or they can simply be included for pictorial balance.

Each season holds its interest. Generally I prefer the winter tree, since the lovely shapes of the branches are shown to advantage and other features, such as farms and bridges, are not obscured by masses of foliage.

Trees as a focal point

Generally, you will find that a tree becomes a centre of interest either because it is a prominent specimen and attracts the eye – almost as a picture in itself – or because you are confronted by a beautiful scene composed of many trees but no real outstanding focal point.

In the latter case, it makes sense to select the most handsome example amongst the trees and to emphasize it more than the others. This can be achieved by making it larger than its neighbours, introducing stronger detail or splashes of brighter colours – I sometimes drop in a strong red into a tree wash to give it a boost, even if it is not present. You can even accentuate the light and shadow.

When incorporating trees as a focal point you have considerable latitude in deciding which ones to include, omit, or move around, unlike a farm or village scene, since many painters feel it is not cheating to move a tree or two. A prominent gateway, section of fence, or perhaps an animal next to the tree can support it effectively. You could even add a puddle for good measure.

Summer foliage

The mass of summer greenery, especially where there are many trees, can be overwhelming for the artist. If you include more than three or four greens, the painting can start taking on the appearance of patchwork, so resist the urge to paint every shade of green you can see. A yellow or red tinge added to a green mass, can, even in summer, improve matters and the copper beech can be a real saviour!

Foliage attracts many shadow areas, which may look fine in reality or a photograph but can be disastrous in a painting. I normally resolve this problem by

▼The tree is a good subject to use as a focal point. In **a** the subject appeared rather dull. Therefore, in **b,** a brighter yellow was used to give more impact and a gate added for support. The introduction of animals would have helped further.

a

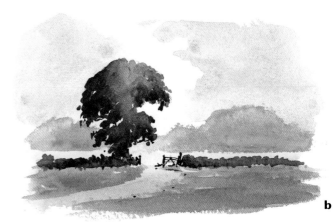

b

greatly reducing the number of shadow areas and unifying those that are included. I do this by placing the shadows on the side away from the light source and adding some shadow beneath the bulk of the foliage mass.

The best time to observe this effect is in the early morning or late evening when the sun is low, and creating this larger and less fragmented shadow mass will greatly enhance your summer trees. Remember to add the cast shadow of the tree and include the effects of other features in close proximity, as even on the dullest of days there is a darker area beneath a summer tree. Autumn trees are handled in much the same way, but use warmer colours and perhaps show more branches.

Winter trees

Here you can accentuate the beauty of the trunk and branches. Are they angular or swept by graceful curves? If the tree is to be close to the foreground, consider the bark

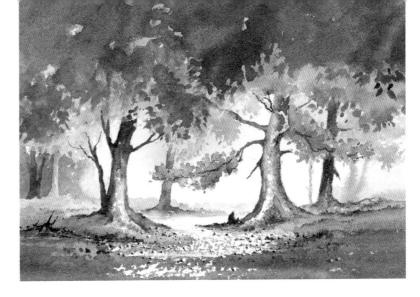

textures and colours, and perhaps how the shadows cast by the branches fall across the trunk. Work outwards from the tree centre with your brushstrokes, towards the extremities of the branches. A No. 1 rigger is excellent for fine branch work, but you will need a larger brush for the trunk and thicker branches.

I enjoy using rough paper in a situation like this because it accentuates the bark texture. It also helps enormously when using the scrubbing technique, which, when

▲ **Summer Beeches**
15 x 21 cm (6 x 8¼ in)
Try to avoid having too many different greens in a painting. Here, I added a little Cadmium Orange in places whilst the green was still wet. I used Bockingford Rough paper to emphasize the foreground sparkle and trunk textures.

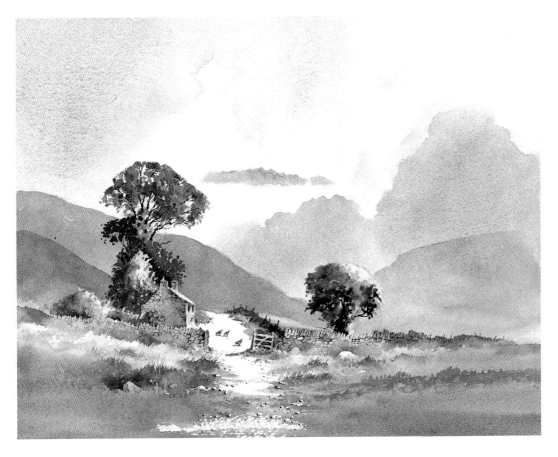

◀ **House in the Yorkshire Dales**
21 x 28 cm (8¼ x 11 in)
Even when you cannot see any trunks or branches in the summer foliage, it is worth adding in a few to give the tree a sense of form. Always bear in mind the direction of the light.

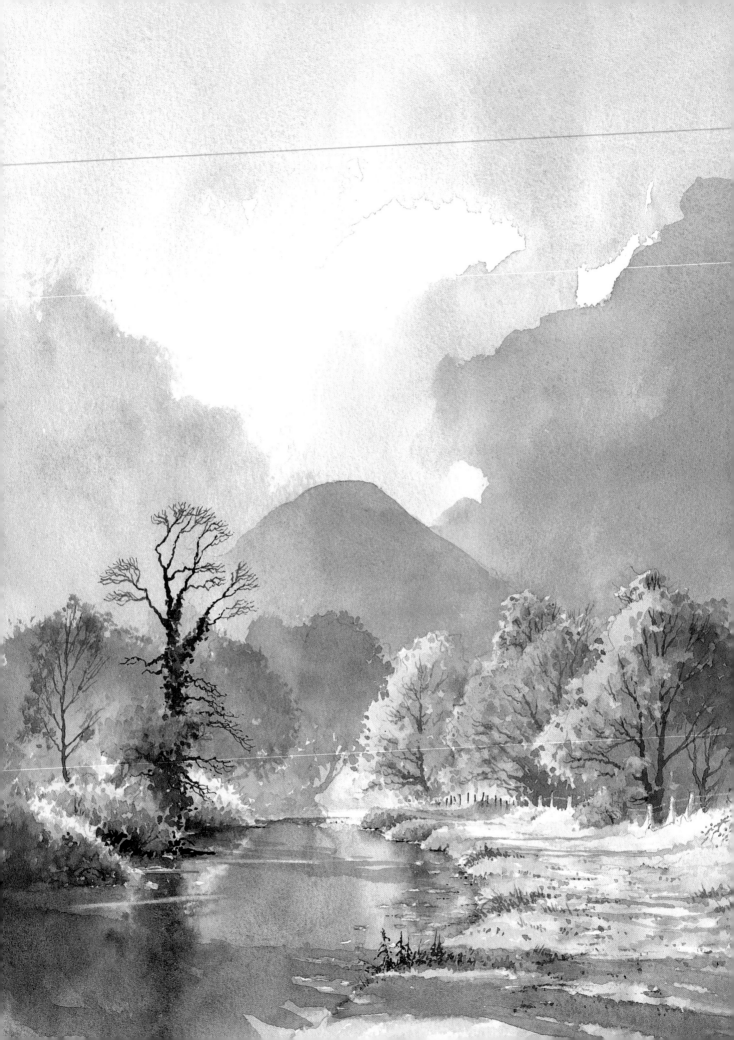

brushing paint with the side of the brush, creates the illusion of a mass of branches. This will automatically create natural gaps in the paint caused by the rough surface. In a foreground tree, try to give it the appearance of depth by making the branches furthest away from you slightly weaker in tone and bringing forward some branches across the trunk. When painting a late autumn scene, a few warm-coloured leaves scattered in places helps to add a sense of time.

Woodlands and massed trees

Painting woodland scenes can be very difficult. Try to simplify the scene by omitting a lot of trees. A misty background with a few trunks rendered with the wet-in-wet technique can be highly effective. Resist the temptation to add more trees. The painting will benefit from a lead-in, such as a footpath, track or stream, which winds out of sight around a prominent tree that acts as the focal point. So many woodland paintings are spoilt by giving equal prominence to many trees.

When you are painting massed trees carefully consider where the mass will end and give the end two or three trees more detail than the others. The painting *Morning Sunlight on the Sussex Downs* on page 38 shows this technique clearly. Broad washes with a hint of tree shapes blending in here and there are more effective than trying to paint every tree you can see.

Choose a few of the more prominent examples within the mass of trees and paint these with their lower trunks and detail softened off into a misty mass. Don't feel you have to cover every square centimetre with tree detail!

▼ **Lane with Birches**
21 x 18 cm (8¼ x 7 in)
Light catching the white on the birch trunks was rendered by using masking fluid. When it was removed, the texture on the trunks was painted in.

◄ **Autumn Tints on the Canal**
27 x 21 cm (10½ x 8¼ in)
Strong sunlight produces cast shadows across the towpath and highlights the left-hand sides of the three main trees on the right bank. Note how the sunlit edges are harder, whilst the shadow sides are generally softer. In each case, the foliage colours were applied first and then, when the paint was completely dry, given shape by defining the shadow areas.

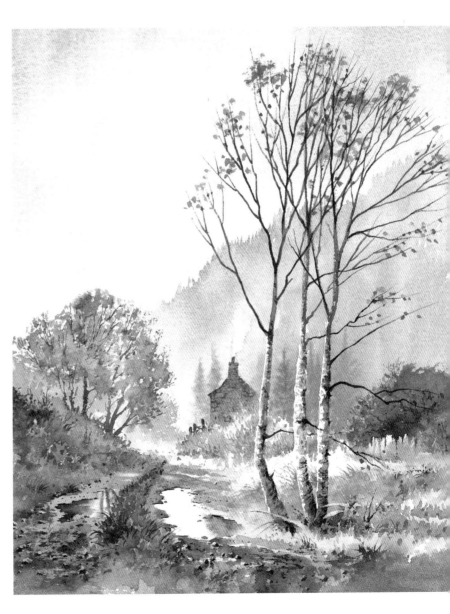

Skies

Skies set the mood of a landscape painting, so it is important to plan your sky before wielding your brush across the paper. The sky present in the actual scene rarely helps the composition, so you often have to resort to changing the sky or enhancing it to complement the landscape. This is especially true if you are working from photographs, since they often bleach out the sky detail. Additionally, the cloud formations can be used to balance a composition, accentuate a focal point or simply act as a backdrop.

If the area of sky is small relative to the overall size of the picture, then a simple sky tends to work best. Large loose washes painted with a mop brush best illustrate areas of blanket cloud or blue sky without any detail. A useful technique is to begin with a light wash of weak Cadmium Yellow Pale or Naples Yellow painted horizontally across the lower sky, and then to immediately drop in the darker cloud bank above it, allowing it to run down into the yellow and creating a lovely loose wash. This will give watercolour its way, encouraging a loose and spontaneous effect.

Integrating sky and ground

Where you have most of the ground detail on one side of a painting then balance can be created by strengthening the cloud formations on the other side. Always consider the sky at the same time as the main composition.

If you wish to emphasize the focal point, direct the most prominent cloud shapes around the area above it, or perhaps create shafts of light leading towards the focal point – this will effectively strengthen the composition. It works particularly well with a hill-top castle, a crag or tree that rises above the main horizontals. This integration

► Practise wet-into-wet cloud studies on scrap paper or the backs of failed watercolours. Try dabbing out with tissues and dropping in strong mixtures of colour at various stages of drying.

▲ **Sunset, River Cleddau, Pembrokeshire**
20 x 32 cm (8 x 12½ in)
Having the lightest part of the sky filtering through trees creates a powerful image. Here Cadmium Yellow Pale was washed over the area where the trees would appear and then blended into a mixture of Cobalt Blue and Crimson Alizarin further down. When the first application was dry, I laid on a stronger mixture of the same colours to create the warmth of the afterglow of a sunset.

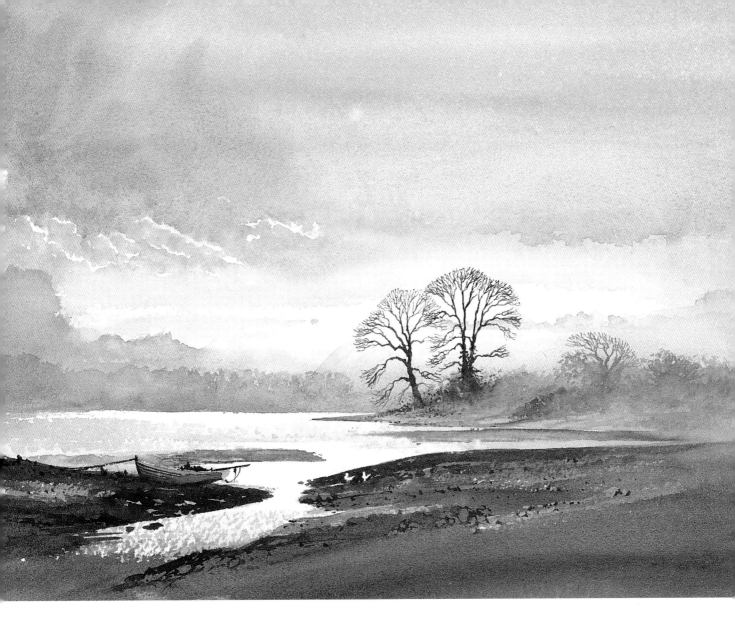

▶ **Essex Farm**
21 x 32 cm (8¼ x 12½ in)
One of the simplest, yet most effective, skies can be achieved by wetting the whole sky area and then laying on a weak yellow wash in the lower part. In this case I used Naples Yellow. Immediately drop in a stronger pre-mixed wash – here it was French Ultramarine and Burnt Umber – right across the top of the sky, perhaps bringing it down further on one side. Don't forget to keep your board at an angle.

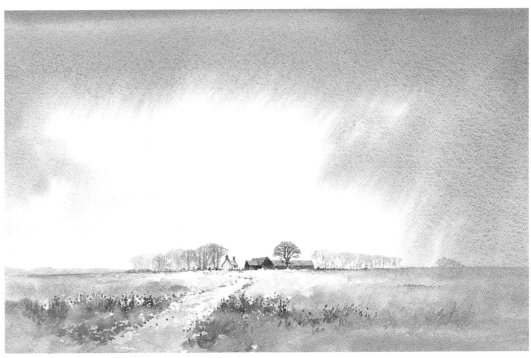

of sky and landscape features adds a powerful sense of authenticity to your work.

It is important to get the transition between sky and ground correct. So many paintings are spoilt by the artist bringing the sky wash down just as far as the distant hills and then stopping abruptly, letting the paint dry and then laying another wash for the hill, trying desperately to abut sky and hill without creating an ugly margin. This is extremely difficult, so bring the sky wash down over the area where the hill will appear, then paint the hill over it once the sky is dry.

If, however, you want a lighter hill, you will need to paint the hill first and then bring down the darker sky over the hill. This can add considerable interest, without over-emphasizing the point, where you wish to introduce counterchange across a background hill or mountain. Having the sky darker than the mountain on one side and lighter on the other can create interest in a subtle manner.

With many monotonous whaleback ridges I often bring in some mist on one side to avoid the ridgeline extending all the way across the painting. This technique is especially striking in the painting of *Tigh Geal, North Uist* on page 63.

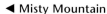

Try some exercises on cloud studies based on the illustrations in this section and other parts of the book, ignoring the ground detail to begin with. Later on you can integrate sky and land.

Multi-stage skies

In order to create more interesting skies, a two-stage or three-stage sky can add more depth. Beware of overworking, however. Whilst you can sometimes get away with an overworked foreground, an overworked or muddied sky will ruin your painting. Again, you need to work out where the most prominent and important clouds will appear. Will they be highlighted dark against light or vice versa? Again, counterchange on cloud formations can be very effective.

It is vital to ensure that the direction of light is constant, and generally most of the time you will find that the hard edges of clouds appear towards the sun. Avoid having hard edges all round the cloud by

▶ **Farm in Arkengarthdale, Yorkshire**
20 x 30 cm (8 x 11¾ in)
The crisp edges of white clouds can only be achieved on dry paper. Here, I began with a wash of Cobalt Blue over the upper sky, immediately adding in some Permanent Rose into the central 'V' and the right-hand side of the paper. When this was dry, I added a mixture of Cobalt Blue and Permanent Rose to suggest harder edged clouds in the centre, then Cobalt Blue and Raw Sienna into other areas of cloud.

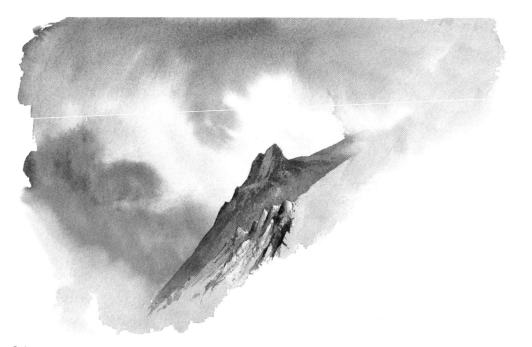

◀ **Misty Mountain**
18 x 28 cm (7 x 11 in)
Use the sky effects to complement ground features. In this sketch I painted the sky first, then the crag. Whilst the crag was still wet I brushed the ridge up into the sky area to suggest mist coming down towards the crag. Alternatively, I could have waited for it to dry and then gently sponged the ridge to give a mist-like impression.

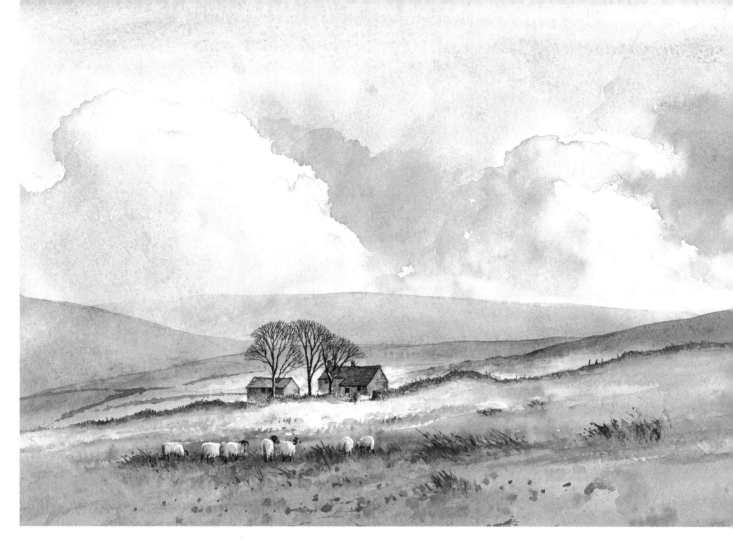

softening them off with a damp brush in places, otherwise they can look like a galaxy of deformed balloons. For those you wish to appear wind-torn, apply the wash with the brush on its side. This can be accentuated further by using rough paper rather than Not. The technique of dropping further colours into wet clouds can work extremely well – for example, where you wish to suggest a shadow beneath a cloud.

▶ **Herefordshire Barn**
18 x 27 cm (7 x 10½ in)
This sky was achieved by completely wetting the paper first and then dropping in a strong application of Cobalt Blue to create the white soft-edged clouds. Lower down I brought in some Naples Yellow whilst the paper was still wet. I then added a few darker clouds with a mixture of Cobalt Blue and Cadmium Red.

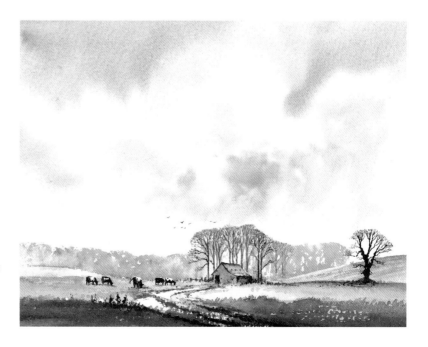

Vallay Strand

By moving away from the subject you can often reduce it to basic shapes and create a much more simplified composition. Whilst this is particularly important when learning to paint, it also has the advantage of giving more impact. There is a wonderful sense of spaciousness in the Hebrides, an aspect that was a prominent ingredient in this demonstration.

◀ First stage

Colours

 Coeruleum Blue

 Naples Yellow

 French Ultramarine

 Cadmium Red

 Raw Sienna

 Light Red

 Burnt Sienna

First Stage

For this demonstration I chose Waterford Not 300 gsm (140 lb). The drawing was first outlined using a 3B pencil. I then laid a wash of Coeruleum Blue over the sky with a large squirrel-hair mop brush, leaving white patches here and there. Whilst this was still wet I brushed some weak Naples Yellow into the lower part of the sky down to sea level. The mountain was darker in tone than the sky so it was unnecessary to stop the yellow wash at the top of the mountain ridge.

Second Stage

Once the washes were dry, I painted the large dark cloud on the right-hand side using a mixture of French Ultramarine and Cadmium Red, again bringing the paint down over the mountain area. I immediately brought in some Raw Sienna below the cloud, allowing the two colours to run into one another. The left-hand cloud was then added and the bottom softened with a damp brush.

After dragging weak French Ultramarine horizontally across the bay, allowing white to shine through in places, I dropped in the mixture of French Ultramarine and Cadmium Red into the sea beneath the left-hand cloud to suggest a reflection.

Once all the washes were dry I took up a No. 10 round sable to paint the mountain

with a slightly stronger version of the wash used for the dark cloud, blending it down into the Raw Sienna on the right. By keeping to a few colours the work is given much greater unity. Again, I waited for this wash to dry before rendering the buildings and the ridge on which they stood with a mixture of French Ultramarine and Light Red.

At this three-quarters stage in a painting it is a good idea to stand away from the painting to see how it is developing – this will also help you to assess whether your tones are correct.

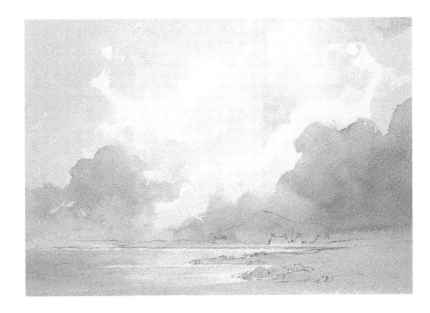

▲ Second stage

Finished Stage

Using a fine-pointed No. 4 round brush loaded with a strong mix of French Ultramarine and Light Red, I suggested some detail on the houses and dark rocks in the water. Stronger Raw Sienna was then dragged across the foreground ground, with some Light Red dropped in in places. The darker sea foreground was achieved with French Ultramarine, Raw Sienna and a touch of Cadmium Red. Finally the foreground rocks were painted in, and the finest detail and birds were added using a No. 1 rigger loaded with Burnt Sienna and French Ultramarine.

▼ **Vallay Strand, North Uist**
22 x 34 cm (8¾ x 13½ in)

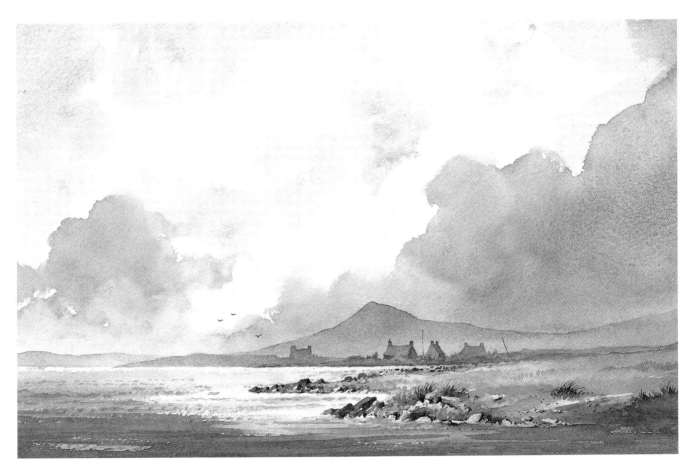

Rendering Water

Water can breathe life and sparkle into a painting, whether it is a tumbling mountain stream, a placid lake, a waterfall, a weed-strewn canal or crashing surf. Even the humble muddy puddle can transform an otherwise dull watercolour painting.

To the beginner, tackling water can appear complicated. However, if you begin with its easier forms, progress should soon be made. As with so many techniques in watercolour, it helps to preserve one's sanity by practising on a scrap of paper rather than trying it out in the foreground of an almost-complete watercolour.

The puddle

A foreground will often benefit from the addition of a puddle because it can break up an otherwise monotonous area or act as a lead-in towards the focal point. Take care when positioning the water, since it usually works best where a feature, such as a gatepost, can be reflected in it.

Strong tonal contrast between water and the surrounding ground accentuates the puddle. Sharp edges will create the same effect although, in places, it can be particularly effective to lose the edge in an indefinite area to create variety and to suggest watery mud.

Breaking up edges with grasses, reeds, boulders and similar features can also vary the interest in the puddle. Counterchange works exceptionally well here, where you can render a dark area of water against light ground on one side, changing the other side to light water against dark mud. Lumps of mud and earth also add interest to the edge of a puddle.

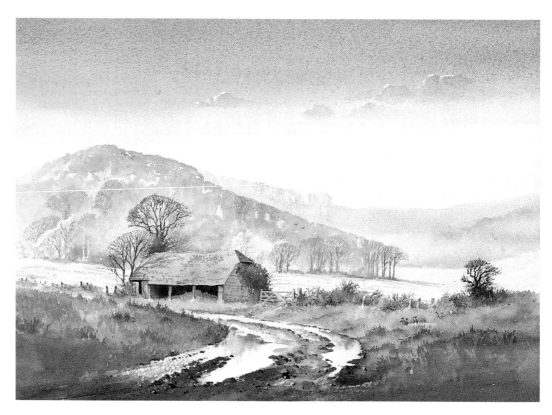

► **Morning Sunlight on the Sussex Downs**
23 x 33 cm (9 x 13 in)
Puddles can bring life to the foreground or middle distance and strong contrasts between water and ground are vital. Observe the left-hand puddle and see how the dark water on the far side describes the edge, whilst the grass bank and dark mud are rendered against the lighter part of the water. Having one or two points where the edge is indefinite helps to relieve the hard edges.

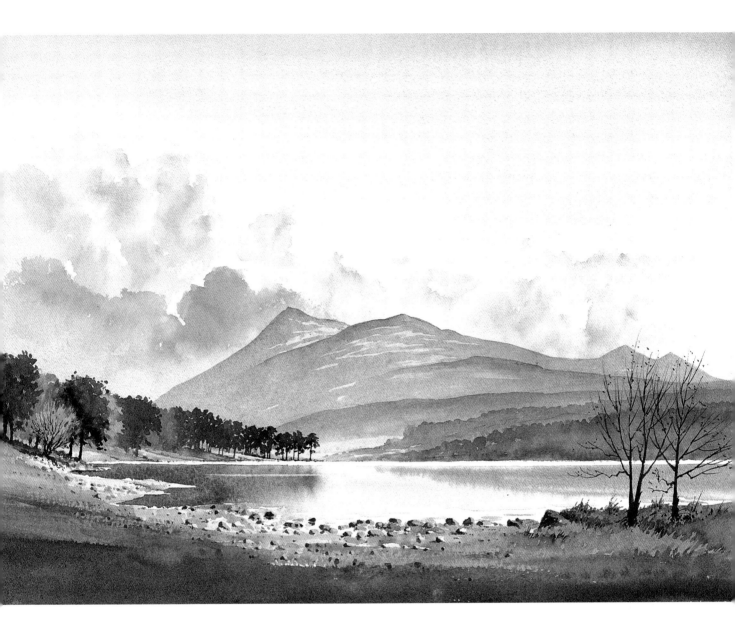

Reflections

I use two methods for creating reflections. The first is wet-into-wet, where I drop the reflecting shape into a wet area. Sometimes, the edges of the reflection need to be tidied up with a damp brush, as the paint may stray outside the area that should contain the reflection. The second method involves painting the reflected object upside down, allowing it to dry and then glazing over the area with a weak wash. This is usually blue-grey, but sometimes I add other colours to hint at reflected colours.

This second method automatically subdues the colour and tone in the reflection, but with the first method you do need to make sure that the reflection is not the same intensity as the actual object being reflected.

Alternatively, you can put in the reflections on to dry paper, but you need to be very accurate with your tones. I find that this technique does not work as well as the first two. It is worth breaking up reflections with one or two horizontal light slivers – these can be pulled out with a damp half-inch flat brush used on its edge. This works especially well on dark reflections but, because it can be highly effective, do resist the temptation to cover the whole foreground with silver streaks!

▲ **Loch a' Chroisg, Northern Highlands**
24 x 35 cm (9½ x 13¾ in)
I laid a weak wash of Cobalt Blue with a bit of Cadmium Red across the loch. Cadmium Yellow Pale was dropped into the central area to reflect the colour to the right of the dark trees. The reflections of those trees were rendered into the wet loch area with a mix of French Ultramarine and Raw Sienna.

Moving water

If it is kept simple, moving water can be easier to render than still water with complicated reflections. The dry-brush technique is extremely effective in rendering sparkling, moving water, especially when it is used in conjunction with rough paper.

With this technique use a large round brush charged with paint but only a small amount of water. Hold the brush at a low angle over the area to be covered and rapidly drag the brush across the paper. It is worth testing that you have the right consistency of paint on the brush by trying it out on the margin of the paper beforehand. After laying it on, soften any hard edges and allow the paint to dry. Later you can paint adjacent darker areas of water, rocks or vegetation.

To create water tumbling over rocks, brush the paint on in the direction of the flow of the water movement, as with any turbulent water, but leave a few speckles of white paper showing in places. This gives a great sense of sparkle and liveliness. Reflected colour can be dropped into the wet area if it is significant.

Waterfalls

Here again, strong contrasts between falling water and the adjacent banks and rocks will help to give a sense of falling water. Soft-edged cascades of water that are set against hard-edged dark rocks work best if they are kept simple. Avoid trying to

▼ **High Sweden Bridge, Lake District** 22 x 28 cm (8¾ x 11 in) Directly beneath the bridge the water is calm and wet-into-wet reflections have been dropped in – you often have to control these with a damp brush to make sure they don't spread too much. Lower down, white patches have been retained amongst the dabs of French Ultramarine and Burnt Umber. Note how, even on a rain-swept day, the tops of the rocks are catching the light quite strongly.

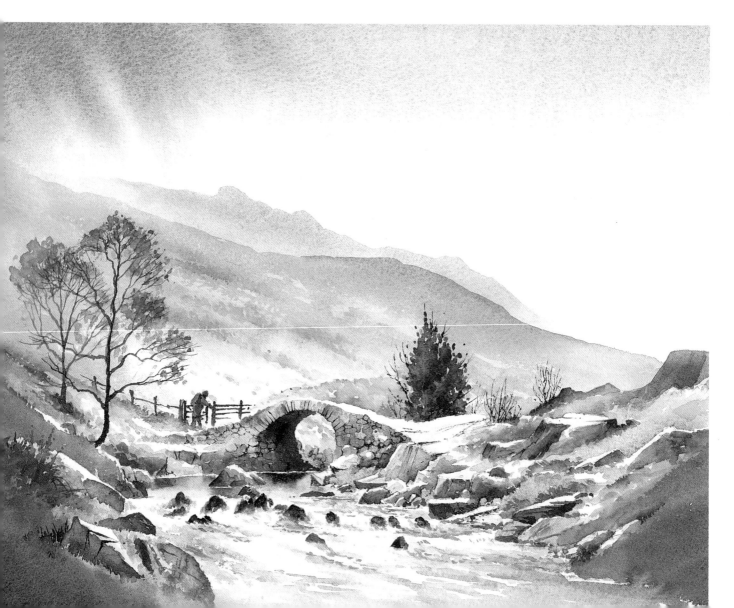

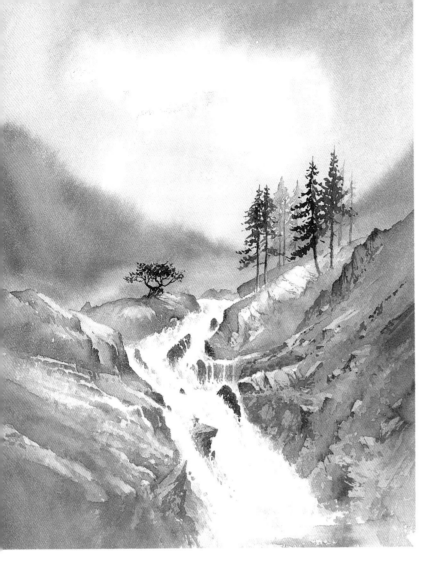

include every nuance of tone within the falling water, especially those intrusive vertical strokes that are so easy to overwork. Where the water falls in front of the rocks, keep the edge as soft as possible.

Rough paper can be useful to achieve the ragged edges of cascading water. Observe how the aerated water at the point where the falling water hits the pool below is generally the lightest part. Don't feel that you have to put every rock into the composition. Watch for any light reflection of the falling water in the pool.

Water can be tricky to render, even for the experienced artist. However, if you keep your washes really fluid you will find your work gradually improves. Remember to look for any colours that might be present in the reflections and drop them in straight away.

▲ **Ogwen Falls, Snowdonia**
20 x 17 cm (8 x 6¼ in)
When painting waterfalls, it is critical to observe the contrasts between tumbling white water and dark rock, and the softness of the water against the hard edges of the rocks. Try not to include every nuance of tone in the water as it is so easy to lose the freshness. Note how the undersides of the rocks soften into the water, with hard edges visible where the rocks come in front of the water.

Try some of the following techniques: the dry-brush method, lifting off a sliver of paint from a dark wet wash with the edge of a half-inch flat brush, and try scratching effects using a scalpel. Paint a series of puddles with a variety of reflections.

▲ **Dornoch Firth**
10 x 22 cm (4 x 8¾ in)
During a wild moment I accidentally brought the brush down too far when rendering the centre part of the far shoreline. By waiting for the paint to dry completely, I was then able to scrape away the offending colour with a scalpel and to restore the shoreline to the horizontal.

Llwyn-on Reservoir

*Portraying water can be a challenge in any medium. Like so
many aspects of landscape painting the end result benefits
enormously from simplification. In this scene an intermittent
breeze was blowing, causing a constant change of ripples
and reflections across the surface of the water. The furthest part
of the reservoir was partly covered with ice.*

► In my original
sketch, much
foreground detail had
been included – reeds
and stones on a spit
of land that jutted out
into the reservoir.
Should I include
these? I decided to
leave them out, as
well as some faint
detail on the left-hand
bank of conifers. The
far right-hand side,
however, needed
something to balance
the composition, so a
studio sketch helped
me to plot a bank of
conifers with
attendant reflection.

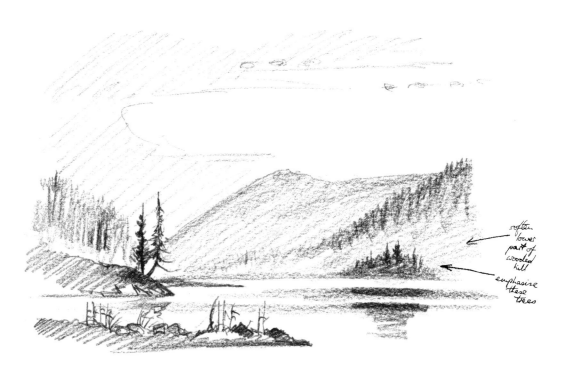

First Stage

For this painting I chose Waterford 300 gsm
(140 lb) Not paper. I began by washing
weak Naples Yellow across the sky, leaving a
white area in the centre. Whilst this
remained wet a mixture of French
Ultramarine and Cadmium Red was
brushed over the lower part of the sky and
brought down over the mountains.

At the bottom of the wash I introduced a
band of Raw Sienna, adding some Cadmium
Yellow Pale in the area where the two large
conifers would appear. The aim of this was

to attract the eye towards the focal point.

As the sky dried a little, but was still
damp, a stronger fusion of French
Ultramarine and Cadmium Red was brought
over the top left-hand corner of the sky,
then dabbed in across the paper to create a
host of small clouds. Note that the brush
was only damp – the paint was quite strong
with hardly any water on it at this point.

This technique works best when the first
wash is just losing its wet sheen. You may
find that you run out of time and the wash
has dried in places before you can render

Colours

Naples
Yellow

French
Ultramarine

Cadmium
Red

Raw Sienna

Cadmium
Yellow Pale

Light Red

Burnt
Umber

▲ First stage

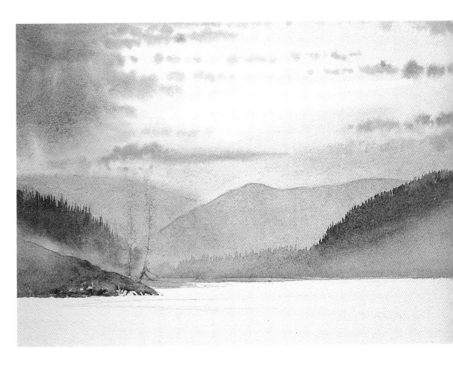

▶ Second stage

further clouds. Simply let it dry completely and then re-wet the appropriate area with a large soft brush. Again, allow it to partially dry and then finish rendering the clouds.

In order to achieve a sense of unity the central mountainside was painted with Cadmium Red and French Ultramarine, adding a touch of Raw Sienna and extending it across to the right. The left-hand mass of conifers was laid with a slightly stronger version of the same mixture, since I wanted this area to come forward more. The whole paper was then allowed to dry before proceeding further.

Second Stage

I used the same mixture on the right-hand tree-clad hill, but I added more water lower down to suggest a soft atmosphere. The left-hand bracken-covered bank needed to

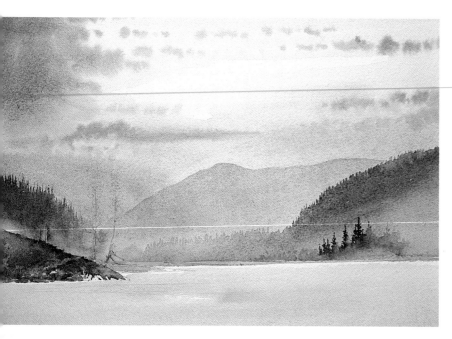

▲ Third stage

come forward to suggest depth, so this was painted with Light Red. However, close to where the trees would appear I splashed in some green and touches of Burnt Umber to define the rocks and to emphasize this section as the centre of interest.

Third Stage

With a combination of French Ultramarine and Burnt Umber the bank of conifers below the right-hand hill were painted in with a No. 4 sable. Note how they stand out slightly more prominently because the lower part of that hill was lightened with water in the second stage – watercolour painting, like chess, benefits from thinking at least one or two moves ahead.

I then strengthened some of the tones on the left-hand bank. To complete this stage I took a large squirrel-hair mop brush and laid a weak mixture of French Ultramarine and Burnt Umber across the reservoir. I then dropped in some Naples Yellow into the centre to reflect the sky colour.

Finished Stage

I painted in the two pine trees forming the focal point using a strong blend of French Ultramarine and Burnt Umber. Finally, the water was rendered with a weaker mixture of the same colours, leaving the light horizontal slivers. Whilst it was still wet, I put in the dark reflections of the trees.

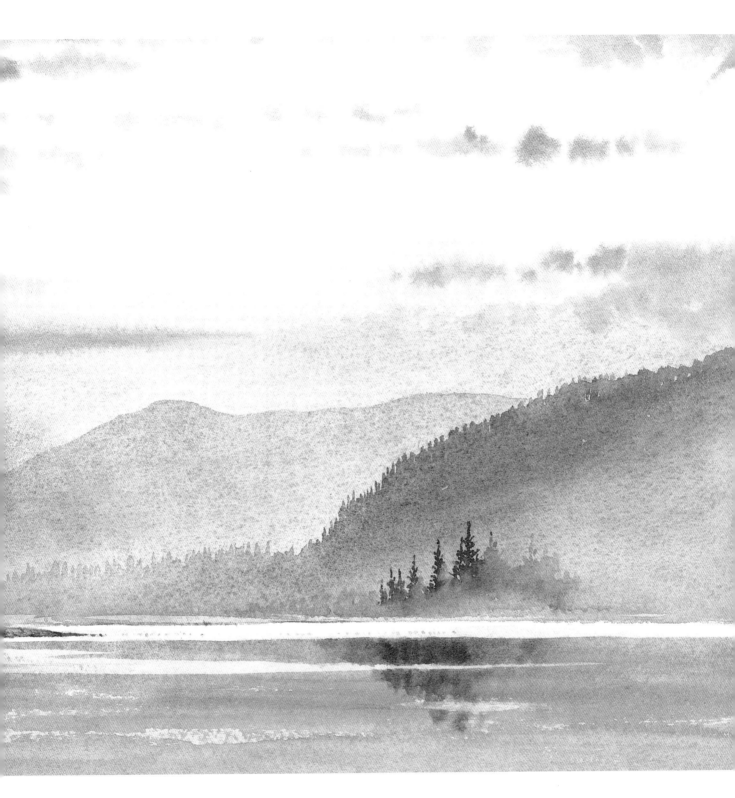

▲ Llwyn-on Reservoir, Brecon Beacons
22 x 33 cm (8¾ x 13 in)

Sunlight & Shadow

Without light there is no form, and unless you carefully consider how light and shadows affect the landscape your work will lack interest. So often you can see a scene which would benefit from sunshine, yet the scene or photograph that you are working from is dull and lifeless. How do you introduce sunlight in these conditions?

Rendering sunlight

Strong sunlight bleaches out detail, produces cast shadows and causes light to be reflected off bright reflective objects. In the early morning and late evening the light casts a warmer glow over the landscape, so at these times you can inject that sense of atmosphere. Strong contrasts and cast shadows will certainly give your composition a feeling of sunlight.

Make sure your shadows are consistent throughout the work and that they do not contradict each other. Look for colours within the shadow areas – although they may at first glance appear to be a dismal medium grey, you can often pick out interesting colours that will make the shadows more vibrant and attractive. It is often worth extending a cast shadow just a little bit further than in the original scene to emphasize it further.

If you are attempting to create sunlight which is not actually present, it helps if you draw a tonal sketch to show the shadow and sunlit areas. Colours in sunshine will need to be brightened up and flecks of white paper also help to emphasize the effect.

Detail will be lost in areas that are bathed in sunlight, so keep detail to a minimum here by simply suggesting it. This is readily apparent in photographs, for example, where part of the image is overexposed, so

beware of copying photographs without careful consideration. At times, two walls at right angles to each other will be illuminated by sunshine, but one side will usually be slightly darker because the texture is caught at a more acute angle than the other. This applies particularly to heavily textured walls.

Controlling light

By being selective about where you want sunlight to fall, you can accentuate features within the painting. For instance, if you wish to heighten the drama of a crag, or perhaps highlight a specific tree, you can place the feature within a light patch and create an area of shadow around it to spotlight the focal point. Of course, it helps if the sky and atmosphere correspond with the lighting effects – a clear blue sky would

▲ **Pembridge, Herefordshire**
16 x 21 cm (6¼ x 8¼ in)
Cast shadows are the most potent way of suggesting sunlight, but make sure they are all facing the same direction! Note the white reflected light to the left of the chimney on the right-hand building.

◄ Rocks catch the light easily because they have reflective surfaces. Here, a dark background shows up the lightness of the top of the rock. Build up rocks in stages and begin with the actual rock colours, which often change and blend into one another. When the first wash is dry, paint any textures and shadows. Finally, detail in the strongest tones of the fissures and darkest shadows.

be out of place, for example, because a 'spotlight' would need to come through the clouds.

Dark washes laid horizontally across the foreground suggest a sunlit middle and far distance – this could be the result of cloud shadow or shadows cast by a tree or building just out of the picture area.

Repaint a scene that ended up rather dull and try to inject a sense of strong sunlight into the new version. Alternatively, work from a dull sketch or photograph that would benefit from brightening up.

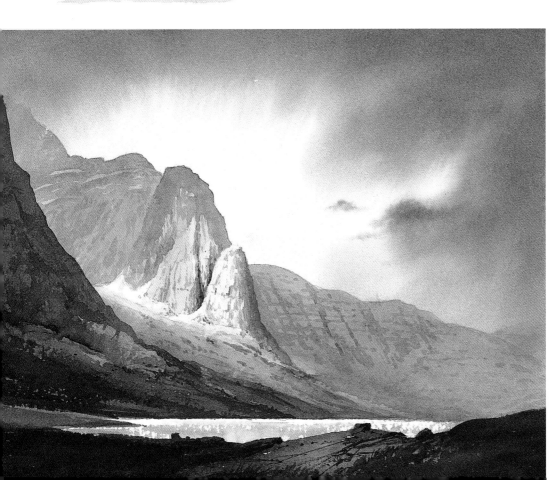

◄ **Loch Coire nan Arr and Sgurr a' Ghaorachain**
19 x 27 cm (7½ x 10½ in)
On a sombre day in the Applecross Mountains a sudden break in the cloud cover brought a cascade of sunlight onto the crags above the loch. By emphasizing the darkness all around, the crags really stand out as the focal point. To help achieve the sparkle on the water and the ground texture I used Waterford Rough 640 gsm (300 lb).

47

Cottage at Kinnersley

This lovely old black and white cottage, unfortunately, looked down onto another garden encompassed within ranch-style fencing that seemed out of keeping with this subject. This was further complicated by the need to create a lead-in to the cottage. I also needed to brighten up what was a particularly dull day and bring some sunshine into the painting.

▶ First stage

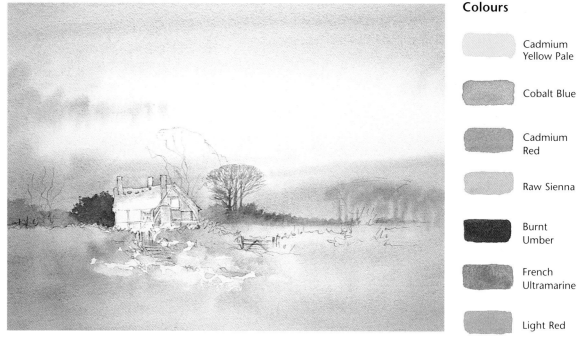

Colours

Cadmium Yellow Pale

Cobalt Blue

Cadmium Red

Raw Sienna

Burnt Umber

French Ultramarine

Light Red

Cadmium Yellow Deep

First Stage

I drew the subject in pencil outline on Waterford Not 410 gsm (200 lb). Then I applied masking fluid to most of the white areas that would be catching the sunlight, which I intended to come from the right. The masking fluid was allowed a few minutes to dry thoroughly before beginning on the painting.

The sky was completely wetted with clean water. A weak wash of Cadmium Yellow Pale was then brushed onto the lower sky, with a stronger version across the right-hand field. Without pausing, a wash of Cobalt Blue mixed with Cadmium Red was painted onto the top part of the sky and a slightly stronger mix of the same colours across the bottom of the sky. I added a fluid wash of Raw Sienna to cover the foreground – I left some parts untouched to give a sense of liveliness.

When all the washes were dry the distant trees and hedgerow were rendered with a medium-strength blend of Cobalt Blue and Burnt Umber. I often use Cobalt Blue for weaker distant features and French

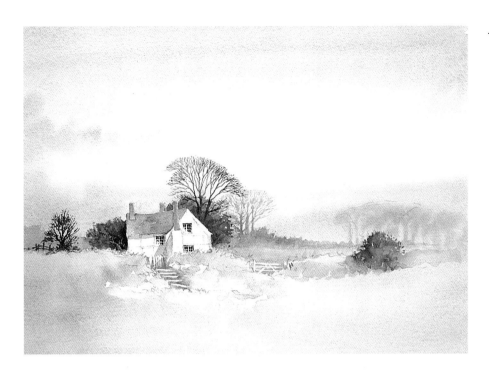

Ultramarine where stronger mixes are required. In this case I resorted to French Ultramarine with Light Red for the left-hand bushes, allowing the red colour to dominate and to imply dead leaves.

Second Stage

The trees were defined with a French Ultramarine and Light Red combination. After the masking fluid was removed I added the shadows with a mixture of French Ultramarine and Cadmium Red. Light Red was applied to define the chimneys. The strong detail on the windows was painted in with French Ultramarine and Burnt Umber.

Once the chimneys were dry a mixture of Cadmium Yellow Deep and French Ultramarine was laid across the roof, with some stronger Light Red and Cadmium Yellow Deep dropped in in several places to add variation.

Third Stage

Further detail was added to the roof and house before the hedgerow colours of Cadmium Yellow Pale and French Ultramarine were painted in, with Light Red dropped in here and there to suggest

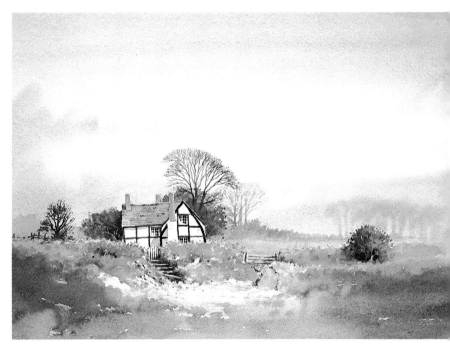

▲ Third stage

variety. Too much detail in a hedgerow can make it look over-laboured, so introducing a change in colour is an excellent substitute for detail.

The gates were then defined, mainly using the colours French Ultramarine and Burnt Umber. Below the hedgerow, I painted a wash of Raw Sienna and French Ultramarine with a little Cadmium Yellow Pale in places.

49

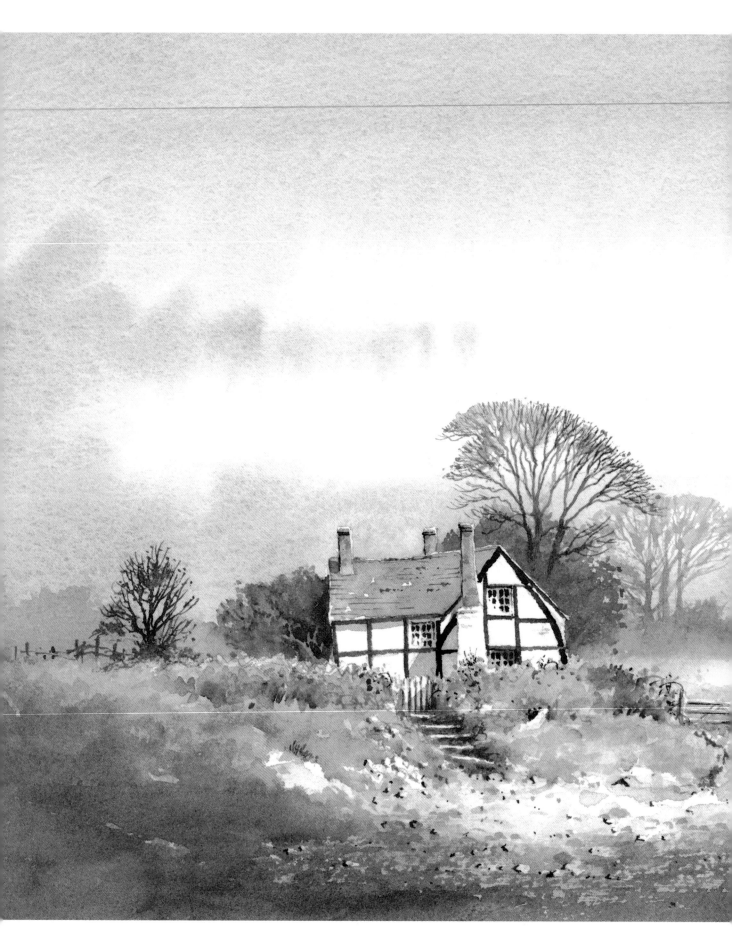

◀ Cottage at Kinnersley, Herefordshire
23 x 33 cm (9 x 13 in)

Finished Stage

Finally, I applied a few more details to sharpen up some features and laid a dark wash of Burnt Umber and French Ultramarine over the foreground in order to accentuate the light around the cottage. When this was dry I picked out a few stones and some detail in the immediate foreground.

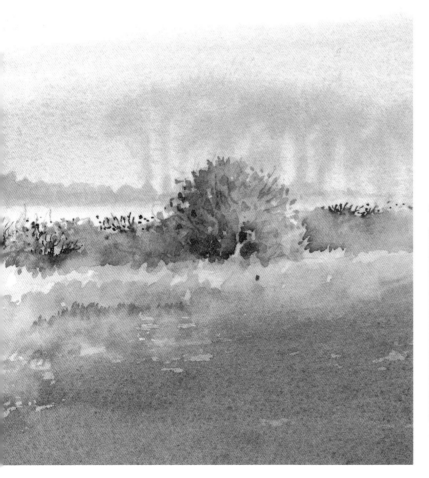

▼ Detail of finished painting

People, Birds & Animals

Many scenes, such as towns, villages and harbours, call out for figures, otherwise a painting can take on a 'ghost town' look. In other types of scenery figures and animals can be used as a focal point, or in support of the focal point, and there are many scenes where some form of life will enhance the work. Therefore, at some stage, you will find it worthwhile including figures or animals in your paintings. Because they do not need to be very big, rendering them is not as difficult as it might sound.

Figures

Figures are powerful tools in a painting because they draw the eye immediately to themselves. Consider figures at the design stage and pencil them in carefully. Make sure that they are in proportion with their surroundings; for example, can they get through that door?

Try to have them doing something, rather than just standing, and make sure they are in character with their environment. Ease off on the detail immediately around figures otherwise they become lost in their surroundings, especially in a complicated section of a composition.

In mountain scenes it is often difficult to know whether to include walkers and climbers, since they can be intrusive to some viewers. On the other hand, they are able to provide a marvellous sense of scale – a lone walker really can make a painting feel desolate if that is what you are aiming for.

If you are unsure about including a figure, paint one in and see how it looks. If it seems out of place, quickly wash it out with a wet brush, dabbing the paper dry with a tissue. Unless you are using staining colours, such as Crimson Alizarin or Viridian, it should wash off. If you experience any problems, try turning the figure into a rock, tree or bush, for example.

Birds

Chickens, cockerels and pheasants can breathe a sense of colour and life into a painting and they can even form the focal point. Birds in flight also tend to help lend a sense of life. Seagulls are excellent for giving

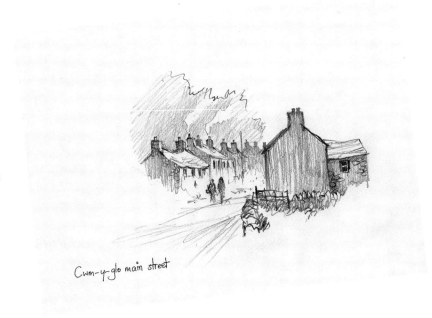

Cwm-y-glo main street

▲ Avoid describing any detail immediately around figures – give them plenty of space, as shown in this sketch – otherwise they simply become lost in the scene.

► Chickens can bring a wonderful sense of life to a farm scene, so it is worth sketching a few in pencil and colour.

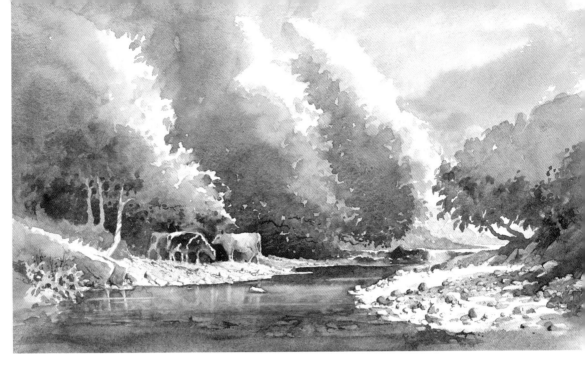

▶ Cattle in the Shade
14 x 24 cm (5½ x 9½ in)
Animals make a superb centre of interest, even when they are quite small within the composition. In this painting they relieve the overwhelming greenery of summer foliage. The paper used was Bockingford Not 410 gsm (200 lb).

a sense of height and drama to a cliff, and they can be rendered dark against a light sky or light against a darker cliff. In the latter case I normally use white gouache for the gulls. Masses of gulls following a boat or tractor ploughing a field can impart a real feeling of movement and dynamism.

Animals

By including a few animals, in fields, for example, you can make a painting come alive. Cattle are especially suitable because they are more angular and easier to draw than horses. Generally, they stand out well against backgrounds, particularly the black and white Friesians.

Sheep, though fairly easy to draw, are sometimes difficult to see in a painting with a light field. As the painter's tonal range is more restricted than that of nature, you have to make the field a little darker in tone than it is in reality. In this way the light-coloured sheep will be more visible. It is also best not to spread the animals all over a field, but to group them together.

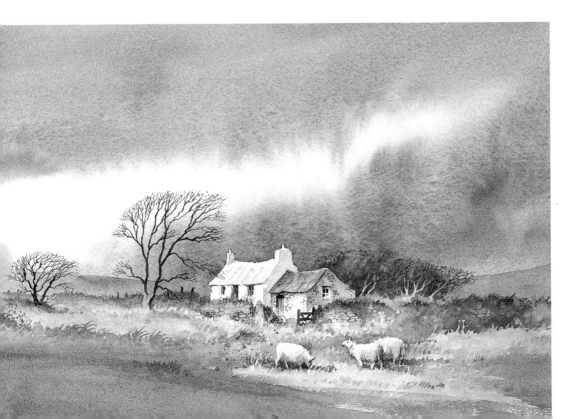

◀ Preseli Farm, Pembrokeshire
19 x 32 cm (7½ x 12½ in)
Naples Yellow is an excellent colour for painting sheep. Here I have dropped a few spots of Raw Sienna into Naples Yellow whilst the sheep were still wet.

Wiltshire Farm

I came across this lovely old farm whilst on a walk. The main farmyard stood behind me as I sketched, knee-deep in mud, but although it teemed with chickens and cattle the concrete walls did not attract my pencil. A mass of wild vegetation separated me from the farmhouse, but most of the detail could be seen.

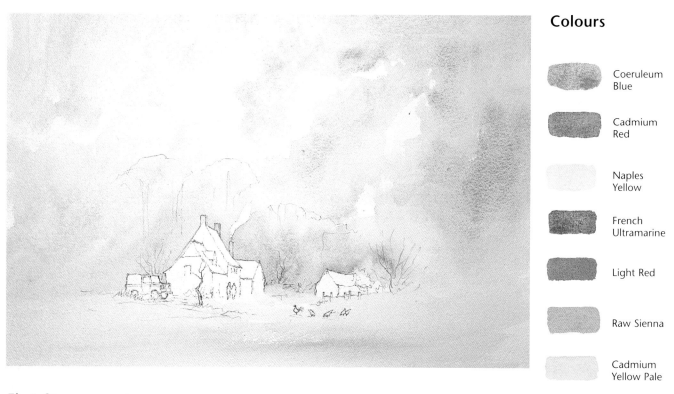

Colours

Coeruleum Blue

Cadmium Red

Naples Yellow

French Ultramarine

Light Red

Raw Sienna

Cadmium Yellow Pale

▲ First stage

First Stage

I washed Coeruleum Blue across the sky, leaving some white cloud areas. Whilst this was still wet I laid on a mixture of Coeruleum Blue and Cadmium Red lower down, with some splashes of Naples Yellow in places.

Second Stage

For the stronger left-hand cloud I chose a mixture of French Ultramarine and Cadmium Red, softening the edge in places with a damp brush. Once this was dry the background trees were painted in with French Ultramarine and Light Red, using a No. 6 round brush on its side to create a more random effect, dry-brush style. Lower down I increased the water content slightly to help suggest a greater mass of trees. Whilst this remained wet I rapidly indicated some of the main trunks to produce a soft effect.

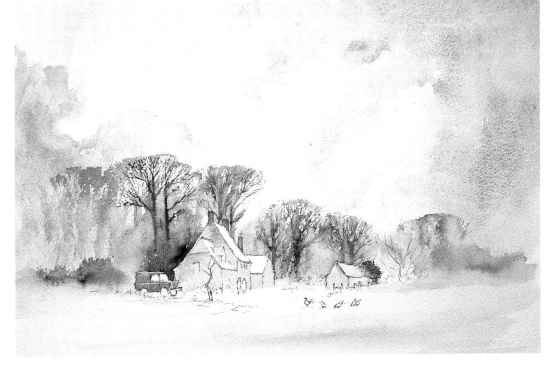

◀ Second stage

The walls and chimneys were painted in with Light Red. A mixture of Raw Sienna and French Ultramarine was used to render the vehicle and the bush by the outbuilding. These did not actually exist in the original scene, but were added for additional interest.

Third Stage

Using a No. 6 round brush I painted the shadow sides of the walls with Light Red and French Ultramarine. When these were dry, I suggested the windows with a darker mixture of the same colours. For the bushes I used mainly Raw Sienna, with dabs of Light Red in places. Dropping warm colours into vegetation is an effective device for introducing variation and interest. I then produced a green by mixing French Ultramarine, Raw Sienna and some Cadmium Yellow Pale, and laid it across the grassy areas.

▶ Third stage

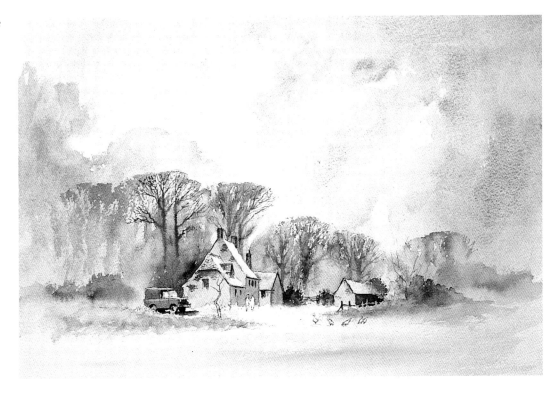

▲ Detail of finished painting

Finished Stage

The bushes were completed by introducing some shadow. I then added the chickens, figures and cow parsley using a No. 4 round brush, although a No. 1 rigger was used for the finest work. The detail was strengthened in several places before laying a foreground wash of French Ultramarine and Light Red to give the painting more depth. I then spattered the foreground by dragging a knife blade across a toothbrush loaded with a darker version of the same mixture. Finally, I flicked in a few larger dabs to suggest the rough ground.

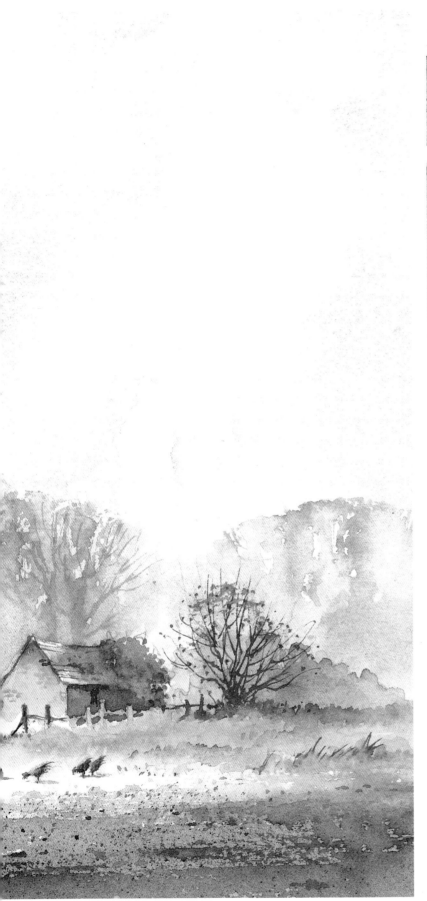

◄ **Wiltshire Farm**
23 x 30 cm (9 x 12 in)

Sketching on Location

Once you have gained some experience in working from the paintings in this book, you will inevitably wish to seek out subjects of your own. Whilst many artists feel that it is easier to paint from photographs, you will learn more quickly if you take a sketchbook outdoors and learn to observe nature directly.

Try not to be too ambitious to start with: sallying forth with easel, a large board and a box of paints announces you as an artist to the world and you will rapidly be surrounded by many people offering the most amazing advice.

First steps

Begin with an A5 cartridge sketchbook and a few well-sharpened 3B or 4B pencils. If you feel timid venturing outdoors, you can hide your sketchpad within a magazine and wear a large wide-brimmed hat. This tends to isolate you from any onlookers. I have found that a few violent sneezes can discourage even the most determined critics!

Look for a subject that has a definite focal point, such as a cottage, waterfall or interesting tree. Walk around for a few moments to find the best view of the subject. Start drawing the feature that excited you most when you first saw the scene and then work outwards.

Draw lightly to begin with to make sure that you include the whole subject, then restate the detail more strongly. Try to avoid constant rubbing out – it is usually easier to apply the pencil strokes strongly once you are confident of the composition and working over any mistakes, rather than pummelling the paper into submission.

When working in monochrome, do make notes about the main colours. Do not be

▼ **Fron Farm, Pant-y-dwr, Mid Wales**
15 x 28 cm (6 x 11 in)
It is useful to filter out unnecessary clutter when sketching.
I eased off the detail at the left-hand end of the buildings so that the fence and cow would stand out.

► After making a number of sketches of this old barn in County Galway, Ireland, I decided to capture the amazing detail that surrounded what was left of this old door. At one point, a rusty old iron kettle had also been pressed into use to hold down the roof. Do go in close to your subject to sketch any interesting detail.

Under the pole and above the door is fixed a sheet of flattened, rusty corrugated iron

← *Two poles holding down the corrugated iron roof with stones balanced on top for more weight*

The hanging larger stones also add weight to the poles, the wire rusting in places

Old Farmhouse Inagh Valley, Connemara

afraid to scribble these notes on the sketch because it should be regarded as a working document rather than a finished work of art in itself.

Consider what you will need to make a painting out of your sketch and perhaps include more detail than you feel you might need. This way, if you do work on a much larger scale when painting the final version, you will be better armed. This is particularly important if you are away at some distant holiday location. Back-up photographs are also helpful.

Constant comparison

By comparing the various features against each other you will gain a much better understanding of a scene. Does that roof appear darker than the background hill? Where does the line of the eaves of the adjacent barn meet the main house? Which side of the building is catching the most light? If a figure is to be included, how high should it appear?

Steer away from relying on lines to define each object by using tones to make the features stand out against each other, although in places it helps to make some of

them merge into one another. In particular, compare the tones on the distant hills or trees with those at the focal point and the actual foreground.

Sketching in colour

Once you have had some experience of sketching with pencil, try charcoal, pens, watersoluble pencils and, once you feel like tackling it, watercolour. A lot can be achieved with a compact box of paints that

▼ **Allt Meallan Gobhar, Applecross**
14 x 20 cm (5½ x 8 in)
Amidst lashing rain, I used a blue-grey watercolour pencil for the background area, much of which was washed off. The black watercolour pencil used on the closer features brought a sense of depth into the sketch.

can be kept in a large handbag or waist bag. A good quality cartridge pad, such as the Lyndhurst, can take washes or pencil, but you may well want to graduate to a spiral-bound watercolour pad. The temptation can then be to produce an almost finished watercolour rather than a sketch.

However, the important thing is to start painting outdoors because it helps your general watercolour techniques a great deal. Outside, of course, you can always blame the elements, the onlookers or even the wild dogs for any mistakes!

There is no need to slavishly record every colour you see. There will no doubt be countless greens to reproduce if you are working in the summertime, so reduce them to a manageable three, or four at most. When the sun appears, make full use of it to create shadows and a sense of sunlight – it might not last long. On dull days emphasize the three-dimensional quality of buildings by making one wall darker than the other, otherwise your painting will appear flat. Accentuate any highlights by making full use of the white of the paper.

Try to include figures and animals because they can breathe life into a painting

▶ **Farm above Bethesda, Snowdonia**
22 x 33 cm (8¾ x 13 in)
Try to bring out the character of the subject by focusing on local idiosyncrasies. This scene is on the edge of the great Penrhyn quarry in Wales that has large waste heaps of slate. The fencing in front of the cottage is made from large slivers of slate, which stood out particularly well against a dark backdrop. I enjoy doing colour sketches like this on cartridge paper.

▶ **Powder Mills Farm, Dartmoor**
20 x 33 cm (8 x 13 in)
In this simple watercolour sketch, painted on cartridge paper, runbacks have formed in the sky, but in a way they seem to enhance it. I used a black watercolour pencil to suggest the detail, so I was able to finish the sketch in a few minutes without interruption.

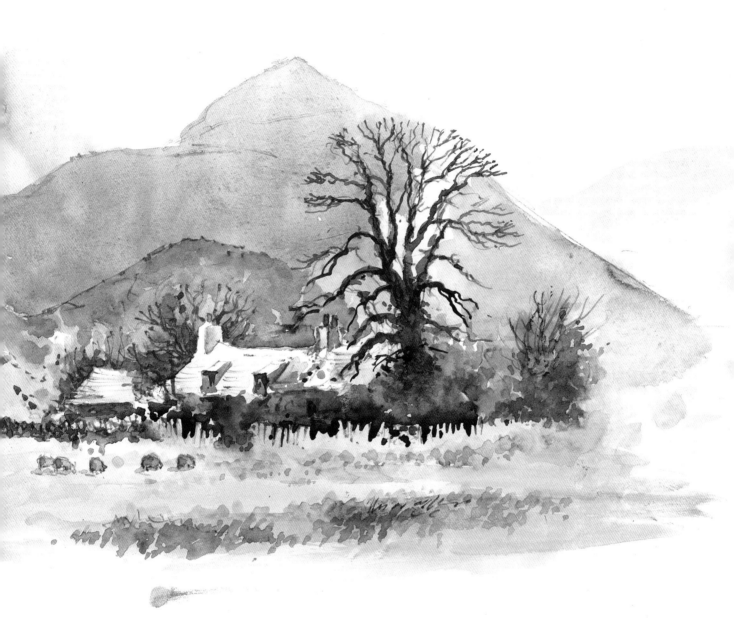

and act as the focal point if there is no strong centre of interest. They are often best sketched in at the side of the sheet you are working on, or on another page, and then added separately into your watercolour. In a landscape, you do not need to make them large and, therefore, they do not have to be highly detailed.

If you still feel inhibited working outdoors, try sketching from a car or a café, or with your back to a wall, to make it difficult for anyone to view your work. Sketching can be the most enjoyable of activities all year round as long as you are properly equipped, so do make a go of it.

Working from Photographs

There are many artists who work not only from other people's photographs, but from postcards, calendars, magazines and the television screen. Others would not think of using even their own photographs. For the housebound and infirm, working from a variety of sources may be the only possible course of action and, indeed, many people are unable to regularly get out to view the landscapes they would dearly love to paint.

Ideally, working directly from the landscape is best – sketching is the most enjoyable of all my activities – but you should not ignore the camera as a powerful tool in producing rapid images. Sometimes there is just not enough time to render a mass of detail with a pencil, so photographs can help enormously to fill in the missing pieces or to check the steepness of a particular hill.

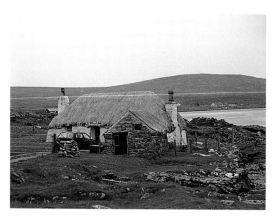

◄ Happily, this traditional tigh geal (white house) is lived in though, aesthetically, the car and modern gate did little to enhance the appeal. They would have to be omitted from the final painting.

Taking landscape snapshots

Many people are disappointed with their photographs and sometimes cannot even see the focal point that looked so interesting in the original scene. With compact cameras, in particular, the image is flattened and pushed back with the wide-angle lens. By using a zoom lens you can close in on

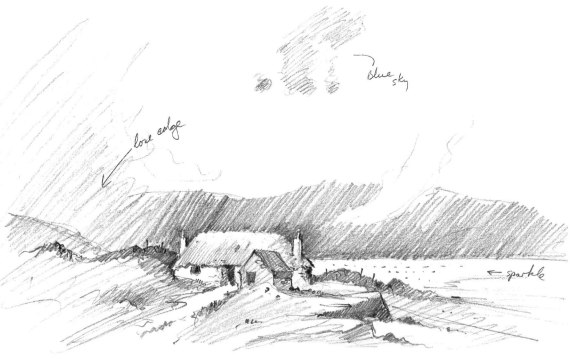

◄ Even though I had an original pencil sketch available, for the purposes of this exercise I wanted to produce a studio tonal sketch from the photograph. Sky detail was totally lacking in the photograph. I also wanted to enhance the water and reduce the effect of the long boring whaleback ridge in the distance. The distant buildings were distracting, so they were left out.

your focal point in one shot and zoom out to get the setting in the next. Close-up shots are vital for capturing detail.

As with sketching, moving around and waiting for the right light will greatly improve your photographs. Look at the scene for a few moments and take your time before taking the shot to analyse potential areas of confusion and to consider the best angle. Photographs taken from slightly different angles can help enormously to ascertain what bit of detail – a chimney perhaps – belongs to what feature.

Look also for the interesting minor features, such as gateposts, tractors and farm animals. Even if these items are photographed separately, they can still be added to a composition. Sky detail usually suffers in photographs – if the sky is interesting, take a separate shot of it, exposing for the sky alone.

Painting from photographs

Try not to copy photographs slavishly because it can make the final painting appear rather wooden. It is a good idea to carry out a sketch from the photograph, then putting the photograph aside and simply painting from the sketch. The resulting image will probably be more lively.

Photographs generally need to be simplified by reducing the amount of detail. Don't feel the urge to copy every colour because this can destroy the sense of unity in a painting. Perhaps most of all, you need to be aware that the tones may well need to be modified if the light was poor when the photograph was taken. Improving this aspect does need experience. By all means use photographs when you have to, but do try to work directly from nature whenever the opportunity arises.

▼Tigh geal, North Uist
22 x 34 cm (8½ x 13½ in)
Here the ridge has been effectively reduced by low cloud, but a patch of blue sky in the centre cheers up the scene. I added sparkle to the water by dragging French Ultramarine horizontally across the paper. The wall to the left of the cottage has been raised slightly and the outbuilding strengthened to bring it forward of the cottage. I also brought the track down a little to involve the foreground.

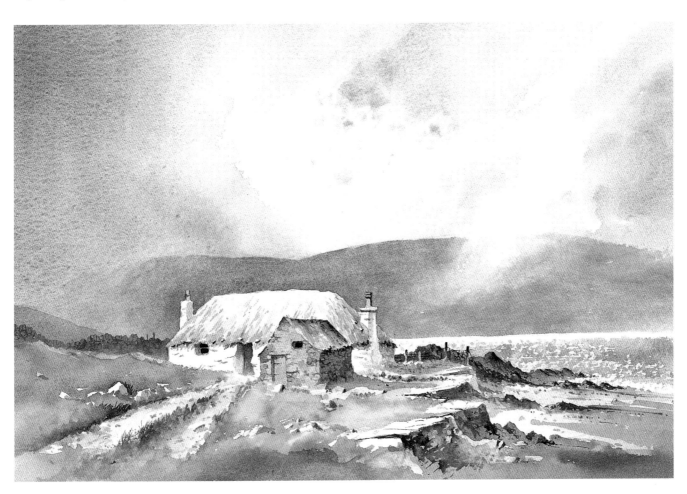

And Finally...

If you have worked your way through the book, you may now be wondering how to proceed. Many artists find that, at times, they can experience a mental block about what to do next. Nothing seems to inspire them.

The secret is to keep the artistic pot on the boil: generate ideas by visiting exhibitions and reading art books; join a local art society or group; sign up on a watercolour workshop or course; but most important of all, keep painting and sketching. The more material you have to work from, the less you are likely to become stale. Try to allocate some time each week to painting – every day if possible. Only with continual practice will your work improve.

When watercolour works it is sheer joy, but everyone has their failures. You cannot expect to be a master of the craft overnight. Start with the more simplified scenes and only gradually, when you have acquired more confidence, attempt more complicated pieces of work.

Keep those failed paintings and put them away in a folder for several months. Eventually, when you take them out it will be more apparent how much you have improved in the meantime. Without the old paintings it is almost impossible to work out your progress. Later on you may feel that you are able to turn them into successes. Most of all, enjoy your painting!

▼ **Harrowing the Field**
19 x 32 cm (7½ x 12½ in)
A broken wash combined with the dry-brush technique works well on fields or mountainsides. Here I have taken advantage of some of the lighter spots by giving them a shadow on one side to suggest loose stones.

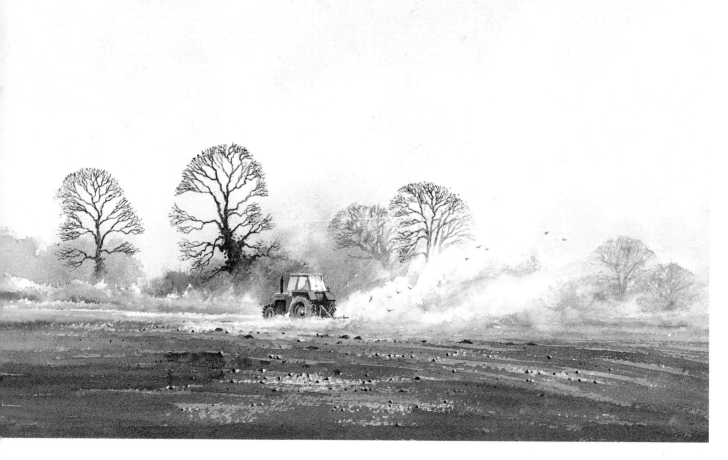